The Intelligence of Art

BETTIE ALLISON RAND *Lectures in Art History*

The Intelligence of Art

THOMAS CROW

The University of North Carolina Press

Chapel Hill and London

The publication of

books in this series is

made possible through

the generous support

of William G. Rand

in memory of

Bettie Allison Rand.

© 1999
The University of North Carolina Press
All rights reserved
Set in Minion type by Eric M. Brooks
Manufactured in the United States of America
The paper in this book meets the guidelines for
permanence and durability of the Committee on
Production Guidelines for Book Longevity of the
Council on Library Resources.

Library of Congress
Cataloging-in-Publication Data
Crow, Thomas E., 1948–
The intelligence of art / by Thomas Crow.
p. cm. — (Bettie Allison Rand lectures in
art history)
Includes bibliographical references and index.
ISBN 0-8078-2453-4 (alk. paper)
1. Art — Historiography. I. Title. II. Series.
N7480.C76 1999 98-29624
701'.18 — dc21 CIP

03 02 01 00 99 5 4 3 2 1

For Hannah, Emily, *and* Juliet, *the three graces*

CONTENTS

PREFACE

This book owes its existence to the kind invitation by the department of art at the University of North Carolina, Chapel Hill, to deliver the first of the Bettie Allison Rand Lectures in Art History. The generous gift of Mr. William Rand, offered in memory of his late wife and her commitment to the arts, represents exceptionally enlightened encouragement for the understanding of visual art in both North Carolina and, through the medium of publications like this one, much farther afield. His personal warmth and memorable hospitality, extended by his entire family, made my time in Chapel Hill an enormous pleasure. I am equally in the debt of Professor Mary Sturgeon, whose imagination and initiative as chair of the department of art made the lectures and this book possible. I can only hope that the results offer some adequate reward for their aspirations and efforts.

I must also thank a large number of colleagues and students at North Carolina who helped me in many ways during my stay and provided much good company and stimulating conversation. I might single out Mary Sheriff, Helen Hills, and Jaroslav Folda, who all gave me a great deal of their time. The very able staffs of the art department, the art library, and the slide and photograph collection cheerfully responded to my many requests for assistance. Research leave from the University of Sussex facilitated the preparation of the lectures; a senior faculty leave from Yale University allowed most of the writing of this book. Mary Sturgeon and Leonard Folgarait of Vanderbilt University, who both read the manuscript at an early stage, saved me from a number of mistakes, as did timely help from Walter Cahn, Stephen Eisenman, and Thomas DaCosta Kaufmann (those errors remaining are of course entirely my own). At the University of North Carolina Press, Elaine Maisner has shown much sympathy and patience in efficiently overseeing the rather protracted transformation of speech into

printed text. During the equally protracted move of my family from England to the United States, which coincided with the writing process, my wife, Catherine Phillips, has shown extraordinary strength and understanding, for which no thanks can really be adequate.

The particular challenge and opportunity presented by the Rand Lectures lay in the need to address an audience divided about evenly between university colleagues and an interested lay public from the area of Chapel Hill, Durham, and Raleigh. In that setting, a report on my own specialized research or an experiment in advanced interpretation felt out of place. It rather seemed the moment to open up academic enterprise in the humanities, my corner of it anyway, to a supportive constituency for higher education, one that is now too frequently excluded by the off-putting vocabularies of professionals and confused by philistine outsiders who have their own reasons for wanting to disable the exercise of humane critical intelligence in our polity. In order to attempt this—and at the same time offer something diverting for a university audience—I fell back on a small group of studies in art history that I most love and whose meaning for me seemed ready to bear some extended explication and analysis. These texts took me far from the territory of my own specialized research, to the art of times and places I could only enter as an interested amateur myself: in attempting to comprehend the scope of even one discipline, we are all amateurs a good part of the time. In keeping with that status, the supporting material found in the notes comes of necessity from readily accessible sources, and none of the models I propose is complex. The lessons of this exercise, I hoped, might then warrant a return to my home ground, where I could try them out on my own account in some clarified frame of mind. If any of this succeeds, it will owe a great deal to the students in my courses on theory and methodology at the Universities of Michigan and Sussex. I will be gratified if they can see something of themselves in what they may read here.

The Intelligence of Art

1 The Intelligence of Art

Faced with a mute work of art, any interested observer enters into a process of translation, making sense of it by some form of paraphrase in thought or words. No one assumes any such substitution to be adequate to the original object in need of explanation; rather, the purpose of the exercise is to offer a vantage point from which salient aspects of the object can be mapped. Going on from there entails further translations or substitutions to capture aspects and features of the object missed by earlier ones. These successive approximations accumulate until seriously diminishing returns set in, at which point the object should be nearly as intelligible as it can be.

The simplest act of substitution is to put the name of a maker in the place of his or her work, which amounts to a paraphrase in itself. A century ago, in an unmapped area like early Italian painting, that basic act was taken to be the primary task of art history. Intuitions about consistencies linking certain works found their readiest concept in the name of the creator, though the very naturalness of this substitution, given our cultural predispositions, can easily disguise its drastic and complex character. All paraphrase sets aside the original: To put the name in the place of the painting is to remove it from immediate consciousness; to narrate the life of an individual is an act profoundly different from looking into a painting and one that cannot be conducted simultaneously with it. To substitute a temporal narrative, already present in a name, for the physical work of art is to give up those features of the thing that were transient and unrepeatable, bound to a moment that is irrevocably ended; the unique instance is, for the moment at least, sacrificed on the altar of continuity.

The maneuver is so commonplace that one rarely reflects on the delicacy and balance it requires in order to be persuasive. There must

be a high degree of intuitive likeness or parallelism between the two phenomena: the art on one side and the life story on the other. But if the substitution entails too great a similarity to the pattern of the original object, the device risks mere redundancy, and interpretation descends to the marshaling of antiquarian details. The interest of the exercise depends upon there being sufficient difference to create intriguing surprises and encounters with the unexpected. In the life-and-work model, these contrary pressures generate certain effects of their own. On the one hand, the work of art will be asked to reveal the life; that means mining the work for clues latent with personal significance: life and work equated. On the other hand, the consequent danger of redundancy dictates that the life must be given a heightened remoteness or drama of its own, so that biographical discoveries can be seen to transform the visual facts as they present themselves to the uninformed eye.

As these pressures have come to seem more and more artificial, naming and biography have lost authority as bases for understanding—at least within the discipline of art history if not with a wider audience. They serve, one is told, the fetishistic demands of the marketplace, which demands names for the sake of commercial classification, and simultaneously perpetuate a mystifying and outmoded cult of genius, which mocks attempts to judge the work through ordinary faculties. But the same degree of sacrifice—with the same attendant pressures on the content of interpretation—has remained at the heart of subsequent approaches toward intelligibility.

Early in this century, the pendulum had already swung toward more impersonal methods of paraphrase. This had arisen in part from the growing prestige of certain subfields of art history—mainly the manuscript art of late antiquity and medieval art—where names were irrevocably beyond recovery. Centers and workshops were the new entities, the new names that scholars were after. The narrative had become one of prototypes and precedents, models and copies, which allowed one center of production to be distinguished from another. Gains in knowledge were manifest, but at the cost of intelligibility becoming even more a shuffling of substitutions, a ceaseless approxima-

tion of like with like and like against unlike. That activity and the close attention to a single moment in the sequence were practically antipathetic to one another. Then, when transferred to other chronological periods, this impulse degenerated into a reflex rightly deprecated by the term "source mongering," an unseemly impatience to outdo the next art historian with some yet earlier model, erasing as rapidly as possible the last object of attention and inserting another into its place.[1]

The increasingly obvious limitations of this approach, even in its home territory, and all the more in a landscape of known creators and rich documentation, compelled a further change in orientation. The impetus came in part from the delayed effects of more recent art—that is, Western art since Romanticism—gaining something like equal scholarly standing with the art of past eras. Any meaningful logic of theme and variation had previously depended upon stable symbolic systems: religious emblematics, humanistic exempla, or princely allegory. An arrangement of lines and colors on a medieval manuscript page can easily have a significant amount in common with a theological doctrine or a lesson in moral virtue: Both sides of the equation are schematic, highly abstracted from experience, and endowed with a legible internal order; there exist mental maps on which both can be simultaneously plotted. By contrast, the increasingly independent and secular art of modernity impels the interpreter to compare some colored pigments on a canvas with vast events like the Industrial Revolution, mass urbanization, or mechanized warfare: The two phenomena—aesthetic and historical—can at best be only tenuously commensurable with one another, in that it is exceedingly difficult to imagine a common mental map with any adequacy to both; a plausible description of one will invariably appear to be dauntingly unlike a plausible description of the other.

At least two generations of art historians nonetheless pursued a broadly social-historical project, and its inherent difficulty makes their considerable successes all the more remarkable. But the inevitable frustrations and exaggerated expectations that came with that project brought on a reaction. Sailing under the fraying flag of post-

modernism, its adherents have asserted that the possibility of making art intelligible requires acknowledging that history has no intelligible pattern of its own. Their preferred terms of paraphrase migrated toward abstruse theories of language: Freud's mental unconscious understood as a structure of language, that is, as the self-governing interaction of repressed signifiers; or the deconstructionists' radicalized notion of the chain of linguistic signs always defeating the writer's intentions, obeying instead its own contrary and autonomous logic. In either case (or in their frequent mix-and-match combinations), the prestige briefly accorded the disciplines of social and economic history decisively shifted toward the literary academy, in particular, toward its efforts to subsume certain local but highly glamorous tendencies in French philosophy and psychoanalysis.

The difficulties of this latter course are proving to be manifold. One of these has been an influx of zealous latecomers with no recollection that many of those who helped launch the new social history of art were equally motivated by the discovery of key texts by Barthes, Lacan, Foucault, and company—and were much quicker off the mark in terms of their original intellectual currency in France. Nor has this historiographical amnesia been mitigated by any perceptible improvement in the general vividness or persuasiveness of art-historical writing.

The response from vocal neoconservatives has been to damn the effects of fashion and the willful obscurantism of an academic guild. But the sheer quality of mind in many who have contributed to this esoteric turn merits a more sympathetic and searching explanation for its failings. One answer might lie in asking whether a particular mode of art-historical inquiry is capable of modifying the terms of its paraphrase. In older modes of interpretation, in reliance on biographies, genealogies of workshops, or archaic iconographic lexicons, this was self-evidently the case. The art historian, with peers and predecessors, largely fashioned both sides of the exchange; that is, they both marked out the visual phenomena under scrutiny and assembled the parallel narratives deemed to explain them, as the latter all lay within their habitual realm of expertise. Social art historians, too, found that ample

opportunity existed for primary research in areas overlooked by "straight" historians, research driven by the peculiar needs of interpreting art but at the same time competent to alter the general picture of a time and place for readers outside their own discipline.

That kind of reciprocity has been in danger of being lost under the new theoretical dispensation. Indeed there has been something of a regression, for the highly technical theories of language and signification deployed by the enthusiastic art-historical convert are not subject to modification in the course of his or her work; this particular vocabulary of paraphrase cannot be remade by the art historian's particular use of it — which is another way of saying that the work of art itself has no independent claim or comeback against the mode of explanation made of it. For that reason, not only unreachable conservatives but reasonable skeptics as well judge that in general this latest form of paraphrase entails too great a sacrifice. The power, they would be right to observe, is all on one side.

But that is by no means reason enough to forgo raising the stakes in interpretation, to attempt much more than the norm in what had been, for a generation at least, a largely complacent and inward-looking field. The proposal of this book is that latent in the best examples of art-historical practice are overlooked guides to a way forward. It asks whether there can be objects of study for the art historian — individual monuments or circumscribed clusters of works — where the violent acts of displacement and substitution entailed in making any object intelligible are already on display in the art. If so, to explain will also be to explore the conditions that make explanation possible — and not through a more or less arbitrarily imported body of theory but through the concrete necessities of art-historical research.

Precisely this achievement unites three of the most successful and challenging works known to me in the literature of the discipline. These case studies will provide the basis for the remainder of this chapter and the two that follow. In each, the object invites and prefigures its analysis; half the genius of the interpreter lies in recognizing that invitation.

.

As with the chapters that follow, this one will take up just one cir-
cumscribed study, but the larger career and identity of its creator will
necessarily intrude. When Meyer Schapiro died in 1996 at the age of
91, he enjoyed an adulation that may in his later decades have been as
taxing as it was rewarding. Intent younger art historians asked him
time and again to recount the genesis of the extraordinary publica-
tions with which he began his career in the 1930s, to rehearse his com-
mitments and interventions in the politics of the Left during the De-
pression, Popular Front, and anti-Stalinist schisms, to recall his warm
and abundant friendships with giants (and peers) in the realms of art,
philosophy, social science, and literature.

For all of that, the wonder of Schapiro's public reputation, given his
achievements and experiences, is that he was not far more acclaimed.
The intense admiration that he so unfailingly commanded was largely
confined to the art world; one suspects that had he been a full-time lit-
erary critic, political pundit, or philosopher, there would already be a
shelf of biographical and interpretative books devoted to him. As it is,
he appears to merit only a walk-on part in the numerous studies of the
New York Intellectuals, while only a handful of scattered articles and
reviews in scholarly publications begin to take the measure of what he
contributed to the intellectual life of this century.

As American intellectuals are famously obsessed and anxious about
their links to the great figures of continental thought, it is all the more
astonishing that Schapiro's activities at the close of the 1930s have not
become the stuff of legend across the humanities. T. W. Adorno, Max
Horkheimer, and Herbert Marcuse, having already transferred their
Institute for Social Research from Frankfurt to New York, took a great
interest in the young professor of art history, and he in them (Adorno
once asked him along to monitor radio broadcasts by Hitler, and
Schapiro made some incisive drawings of the Institute's fellows as they
gravely attended to the voice of the enemy). As proponents of an in-
dependent Marxism, they had no doubt been impressed by the coura-
geous objectivity he had shown in assessing the growing evidence of
Stalin's murderous purges and show trials. In 1939, Schapiro was em-

barking on an extended research trip to Europe, and these expatriate intellectuals marked their respect for him with the most profound trust: Could he succeed, where they had failed, in persuading Walter Benjamin to leave Paris for safety with them in New York?

When Schapiro and his wife, the physician Lillian Milgram, arrived in Europe, they saw ominous signs of preparation for war everywhere they looked; the news of the nonaggression pact between Hitler and Stalin seemed to remove the last restraint on Germany's aggressive designs. Schapiro telephoned Benjamin, and they agreed to meet at the Café des Deux Magots. The latter dismissed any concern about their recognizing one another; as Schapiro recalled the encounter:

> Lillian and I were sitting in the café waiting to hear from him when I saw a man walking up and down the sidewalk, looking at all the people and holding up a little copy of the *Zeitschrift für Sozialforschung*, the social research volume. So I called out to him . . . "Benjamin?," and he said, "Schapiro." He came down and sat with us, and we talked about everything under the sun. He decided that it would be too hard for him to live in New York, even though so many of his good friends that he had been very close to were there.[2]

One suspects that if the animated, erudite, and multilingual art historian could not make life in New York seem inviting to Benjamin, then there was truly no hope in diverting him from the fatal course he chose to follow—only in 1940, with the fall of Paris to the Germans, did he attempt to escape to America, only to lose heart when told that the Spanish border was closed and take his own life. Schapiro himself kept to a promise made to his wife and cut off his sabbatical at the outbreak of war a few weeks later: They boarded one of two liners setting out from Belgium; the news soon came that the other had been sunk.

Nineteen thirty-nine, the year of his truncated European journey and futile mission to Benjamin, also saw the publication of his two landmark articles on the interpretation of Romanesque art in southwestern France and northern Spain.[3] One of these, which investigates the dramatic disparities in style between manuscript illumination and

stone sculpture at the Spanish monastery of Silos, has enjoyed the larger share of attention and acclaim. But the other, entitled "The Sculptures of Souillac," offers both a more distilled example of Schapiro's analytical procedures and a layered allegory of his own outsider's position within the developing discipline of art history in America.

To begin with the latter of these two dimensions to the work, it needs to be recalled that art-historical teaching was still relatively rare and novel in the university curriculum, not only in America but in most countries outside of Germany and Austria. The latest wave of influential German scholarship, advanced in the writing of Wilhelm Vöge and Adolph Goldschmidt, centered on the Middle Ages rather than the well-rehearsed fields of the Renaissance or Greco-Roman antiquity.[4] The most influential American adherents to the discipline—among them Arthur Kingsley Porter at Harvard—were likewise redirecting its core commitments toward medieval art, which struck them as both emotionally moving and full of potential for fresh discoveries. The destruction of medieval monuments during the First World War lent urgency to their scholarly endeavor, and Porter, for one, went to France to assist in their reconstruction. At the same time, this commitment carried a contemporary polemical edge. Porter championed the acquisition of medieval objects for American museums, along with the expansion of education in art history from the elite universities into the schools of the country, as a counterweight to "the hated materialism, individualism, and Philistinism" of the modern age, along with their symptoms in the "superficial" novelties of Post-Impressionism, Cubism, and Futurism.[5] He imagined instead a spiritual art arising out of—and reinforcing—a harmonious social order built on values of humility and obedience.[6]

Schapiro's relations with Porter, who laid the foundations for the serious study of Romanesque art in America, were complex and inevitably ambivalent. The latter's monumental study published in 1923, *Romanesque Sculpture of the Pilgrimage Roads*, had been an implicit challenge to certain authoritarian tendencies in the reigning scholarship of France: First of all, it failed to display unquestioning deference to the existing, nationalistic accounts by revered French art historians;

second, it queried their assumption that lay stone carvers worked exclusively in obedience to dogmatic dictates handed down from their ecclesiastical patrons.[7] From that chink in the edifice of established thinking, Schapiro would eventually open up a new, far more realistic world of medieval practice, one in which the conflicts and strains between competing interests would receive their rightful attention.

And Porter did not stand in the way of that goal. The older man, with his comfortable inherited wealth, in many ways stood for the WASP ascendancy that then dominated the Ivy League universities, but he went out of his way to be generous toward his young colleague, who shared nothing of that background. He offered encouragement (expressing the wish that Schapiro might study with him at Harvard), shared research, proposed collaborations, and softened potentially bruising encounters with his own Brahmin world (when Porter and his wife returned in 1932 from one of their lengthy stays in rural Ireland, Schapiro was waiting on the dock to meet them).[8] At this stage, both of them advocated a return to art that robustly celebrated the shared aspirations of a community, but their views on the social and ethical makeup of that community could not have been further apart.[9] Porter had resigned his Harvard position and withdrawn to Ireland out of a growing, publicly expressed abhorrence of democratization in American universities and in political and economic life in general (even such pre–New Deal reforms as the progressive income tax infuriated him[10]). The futility of inculcating a dream of premodern order—even within the sheltered confines of an Ivy League university—had become unbearable to him. When Schapiro greeted him in 1932, Porter was returning from Glenveagh, his Irish castle and landed estate, where he surveyed with satisfaction the piety and outwardly simple lives of the surrounding inhabitants.[11]

Schapiro, as a young Jewish scholar from a striving immigrant family, was the purest product of the democratization of higher education. While he too had attempted to experience something of medieval life firsthand, he drew forward- rather than backward-looking conclusions from his experience. A period of living among the monks of Silos, one of the great Romanesque monasteries of northern Spain,

convinced him that art history—including his own dissertation on the abbey of Moissac—was hobbled by its failure to theorize the relations between visual form and the complex of social interests within which it was embedded. And he looked for an answer to that failure in the theories of Marx, seeing in bourgeois emancipation from Porter's beloved feudal society a model for a further stage in the human creation of an egalitarian economic and political order.[12]

.　.　.　.　.

At a cusp around 1930, then, the two most influential American scholars of the Romanesque were undergoing spells of disillusionment with the effectiveness of their work and with the larger world in which it functioned. And each of them worked his way through that state by fixing on the same medieval miracle story: the apostasy and salvation of Theophilus Adanensis, which had its origins in sixth-century Asia Minor. The Greek-language account by Eutychinus of Adana became available in the West via a much-copied Latin translation by the Italian monk and historian Paul the Deacon (c. 725–c. 800).[13] Porter took it up as the theme of a play (not his first), which he published in 1929 and entitled *The Virgin and the Clerk*.[14] His plot follows the traditional outline of the legend: Theophilus, a lay officer (*vicedominus*) of the Church, begins his career as a pious and selfless idealist but finds himself abused for his humility by the holder of the bishopric that had first been offered to him; in revenge he sells his soul to the Devil for a restoration of his position and worldly success, but, ultimately, forty days of painful fasting and penance alone in a church dedicated to the Virgin undoes the bargain when she returns to Theophilus his bond with the Devil. He then confesses his sin to the bishop, publicly burns the restored pact, takes communion in the cathedral, and dies three days later in a state of blessed happiness. Porter, however, added his own novel and sour twist to the ending: His hero—renouncing his career at the very point when the Papacy itself beckons, and retiring to compose a hymn to the Virgin—is then amazed to encounter her in person bearing the infernal contract for his soul in her hand. But, far from rejoicing at her intervention, Theophilus is dismayed at her hav-

ing had "profitable dealings" with the alien Devil and leaves his hymn unwritten.

Porter's jeremiads are rarely simple plutocratic rant. He abhorred the influence of commercial markets on the shape of high culture, as well as the competitive self-aggrandizement through art collecting pursued by many of his social peers. On these grounds, Schapiro might have found reasons to sympathize with the message of the play. But his dismay would have been great when he encountered Porter's Devil appearing in the person of a Jewish dealer in manuscripts.[15] A reply to such prejudice was complicated by both Porter's personal generosity and his premature death in 1933, when he mysteriously disappeared while boating off the coast of his Irish refuge. None was forthcoming for ten years following the appearance of *The Virgin and the Clerk*, but, when it came, it signaled an end to Schapiro's doubts about his direction. Moreover, it took as its topic the first and most extraordinary artistic retelling of the Theophilus legend in the medieval canon: the portal sculpture of the abbey church of Sainte Marie in the southwestern French town of Souillac (fig. 1).[16] By celebrating the same legend in which Porter had packaged his splenetic rejection of modern life, Schapiro could celebrate scholarship of his predecessor yet conspicuously withhold endorsement of the deluded social vision that went with it. In an act of inspired critical homage, he submitted his article on the Souillac portal to the posthumous Festschrift published in Porter's honor.[17]

It is highly likely that the complications entailed in this delicate operation advanced rather than impeded its intellectual success. Both Porter and Schapiro found in the Theophilus legend—a tale of betrayal and apostasy with an ending that is at best ambiguous—a matrix in which to project the difficulties each faced in reconciling scholarly imperatives with the compromised reality around them. Schapiro's "The Sculptures of Souillac" advances an implicit hypothesis that the most productive cases in art-historical inquiry will involve objects that already exist as disruptive exceptions against a field of related works of art that surround them.

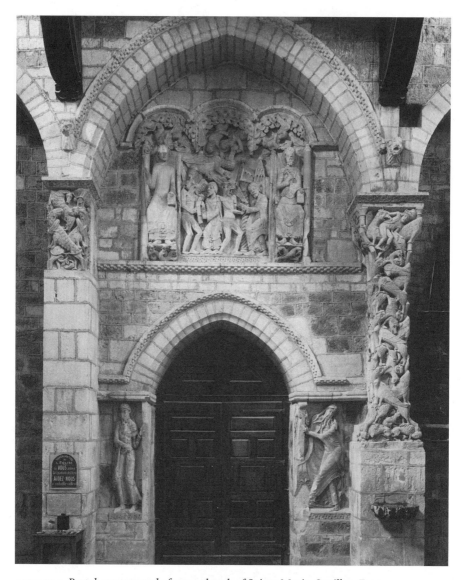

FIGURE 1. *Portal, western end of nave, church of Sainte Marie, Souillac, France, photograph courtesy of James Austin.*

· · · · ·

How then did the actual stonework at Souillac so identify itself? First, the sculpture poses from the start the most basic archaeological problem: At some point in its history the entire complex was displaced from its expected location on the outside of the abbey church to the

interior. So the first question to be settled is whether all the pieces of the main sculptural group are in the right place. Schapiro pronounced himself satisfied, from the outward evidence of the masonry, that the existing sculptures indeed constituted an original unit and, further, that they belonged in their elevated, central position above the portal.[18] But he still had to explain a more profound displacement on the level of theme and composition (which had raised the archaeological problem in the first place). Romanesque tympana were invariably organized around the hieratic and centralized image of the judging Christ, with illustrative examples of sin in mortal life supplied in diminutive form around the margins; the sculptor or sculptors of Souillac reversed this whole arrangement (fig. 2), placing "the dramatic vicissitude of a single intriguing individual"[19] at the center and pushing the divine intervention of the Virgin to a precarious edge (in an engaging touch, she is unable to fly and has to be held up by the angel). Christ plays no personal part in the story at all.

Prompting the doubts of those who questioned the integrity of the current arrangement of sculpture was the startling quality of the unsupported trefoil arch over the entire ensemble, which at an initial glance seems more the result of freehand improvisation than weighty composition in stone. The three arcs roughly mark out the division between the figures below, where the stable and rigidly frontal poses of the two seated saints (Peter, as the first pope, and possibly Benedict, as the founder of monasticism) no longer signal centrality, the middle field being occupied by "active and uncentered profile figures."[20] Across the principal band of the composition, one follows the drama of the temptation of Theophilus and the sealing of the bond with the Devil as in a feudal pact; the shape of the demon changes as his basest nature is revealed in (temporary) triumph (fig. 6), "assuming a more predacious character by an astonishing conversion of the features into flamboyant, centrifugal, tentacular curves. . . . The lines of the Devil's snout and jaw flow into the curves of the capital surmounting the column, and thus to the bowed, not opposed head of Theophilus."[21] The Devil's conspiratorially enveloping wing on the left turns into a stabbing blade on the right.

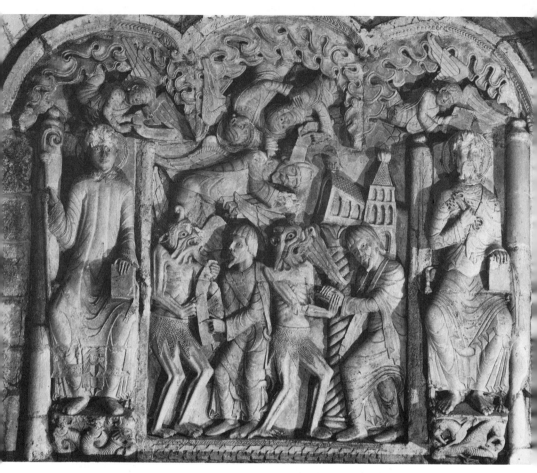

FIGURE 2. *Portal detail, tympanum, church of Sainte Marie, Souillac, France, photograph courtesy of A. Allemand.*

Obeying the same logic of lateral transformation is the asymmetry between the two saints, who stand for the simultaneously ecclesiastical and monastic context of the art: the "more relaxed, compact" shape and pose of the saint on the left giving way to "the more tense and vehement" Peter on the right, a contrast dictated by the governing formal order of Theophilus's story rather than any theological or historical distinction.[22] That peak of dissonance at the right edge then has to be resolved, which happens across a diagonal axis marked by a symmetry between the damned body of the mortal and his reappearance as a repentant sleeping figure outside the diminutive church that shel-

ters him in the story. From that directional turn comes the logic of the overarching trefoil springing from right to left and the angle of the Virgin's redemptive descent. In what seems at first glance to be a haphazardly additive composition, Schapiro discerned a fiendishly intricate governing order beyond the imagination of his art-historical colleagues seeking after symmetrical triangles. He called the mode of composition in evidence at Souillac "discoordinate": "a grouping or division such that corresponding sets of elements include parts, relations, or properties that negate that correspondence" but, he might have added, reestablish a higher form of coordination out of this rhetoric of discrepancy.[23]

True to his refutation of automatic priority of the center over the margin, his most incisive characterization of the artistic logic of the whole comes in his description of the fabulous trumeau, the decorated column now placed asymmetrically to the right of the portal (figs. 1, 3). Freely conflating precedents in adoring beasts around a ruler's (or Christ's) throne with the tormenting demons of Hell, the sculptor created an architectural composition out of helpless victims being torn and devoured by fierce griffins and lions. A supine male figure, mostly naked and set upon by a pair of beasts, crowns the composition in its quasi-capital; below him, vertically suspended animals constitute the prey. Each of the predators wraps itself double around one of the fictional colonnettes, which appear distended into scalloped outlines by their ferocious pressure (fig. 4). The pattern of the trumeau, he writes,

is not simply a network of ornamental lines to which the figures have been submitted. The beasts are twisted, entangled, and unbalanced by their own rapacious energy. Every motion issues naturalistically from its opposite. The intensity of the beasts, their almost supernatural vehemence, lies in the deforming oppositions generated by impulsive movements. In his divided posture the beast acquires a human complexity and inwardness, like a Christian with his double nature. The diagonal crisscross pattern, the interlaced scheme, and the scalloped verticals are the inspired devices of this

tense, congested struggle. They are material aspects of the beasts, or physical elements like the sagging colonnettes, real situations of tension, instability, obstruction, and entanglement, even if repeated in the sense of ornament.[24]

This "passionate *drôlerie*," as Schapiro termed it,[25] runs far beyond—even at odds with—the requirements of dogma. In the case of the Souillac tympanum and trumeau, the object of analysis here is literally diabolic. The greater part of the space and energy in the tympanum is devoted to the Devil's triumph, overcome only in a muted and conventional epilogue. And in another tour de force of observation, Schapiro compels the reader's attention to the small feature under the feet of St. Benedict, a coiled serpent from which the heads of three demons protrude (fig. 5). Its direction and the double scale of the emergent heads reproduce the contrasts in the central field, while the rhythm of symmetries and reversals in the heads and coils mirrors the discoordinate arrangement of the figures in the celestial register, a correspondence of part to whole extending down to the large head alone, which "reembodies within the fantastic bifurcation of the beard the inner oppositions of the demons." Because these monstrous forms "are so small and so minor an element in the whole," he observes, "they reveal to us all the more deeply in their minute distinctions and powerful fantasy and in the pervasive contrast of corresponding parts the sculptor's independence of an *a priori* architectural form and his conscious method of design, with its virtuosity in variation and intricate juggling of symmetrical schemes."[26]

In a parallel—and monumental—article on the art of the Silos monastery published in the same year, Schapiro revealed that he probably knew as much as anyone living about the medieval lore and arcana of demons.[27] But in this instance, his exegesis of the Souillac sculptor's (or sculptors') invention proceeds independently from the iconographer's traditional matching exercises. His procedure was to

FIGURE 3. *Portal detail, trumeau, church of Sainte Marie, Souillac, France, photograph courtesy of James Austin.*

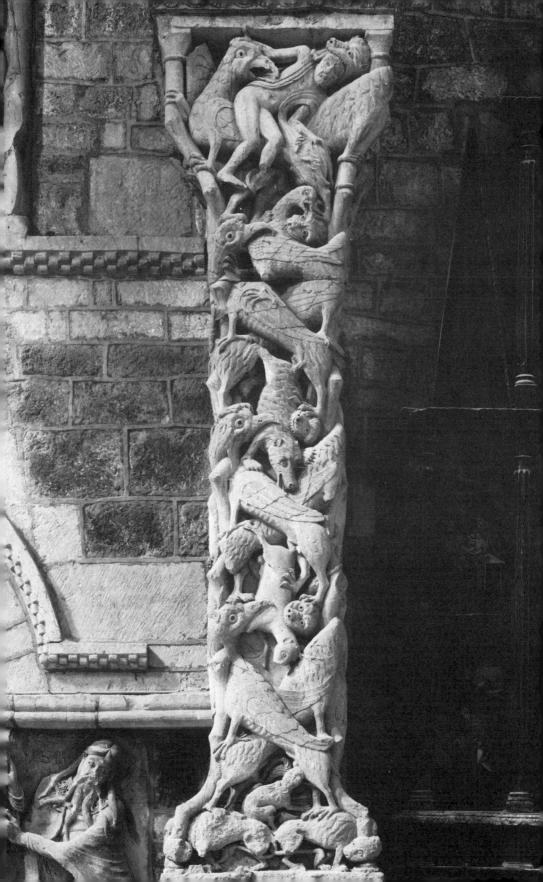

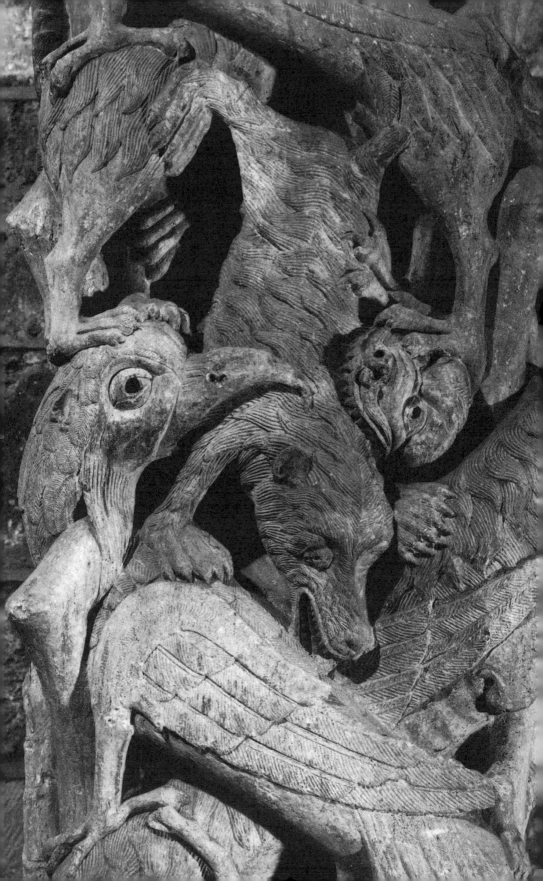

build a new system for decoding aesthetic form, one in which there is no question of the artist's formal decisions being a secondary embellishment over a given model: There is no known model for this tale appearing in this place, so every formal feature of the sculpture becomes an enactment or creation of meaning. He builds his analysis from fundamental oppositions between traits or qualities that have little or nothing to do with the Christian story: lower versus upper; left versus right; open versus closed; loose versus tight; blunt versus sharp; human versus beast; mortal versus immortal. Each opposition is elementary in itself, entirely pre-aesthetic in character, but the cross-mapping of this limited set is enough to provide a convincing logic—and thus an explanation—for nearly every formal decision that entered into the fashioning of the narrative.

To take one further example almost at random, the diagonal axis, across which the hero's apostasy turns into redemption, also follows the line of the second Devil's bestialized snout; and that line is further fixed by the symmetry of the Devil's two wings, which participate in yet further play of subtle theme and variation, linking but differentiating the damned from the saved Theophilus (fig. 6). As Schapiro puts it (and there are a lot of twists and turns here): "If the right wing is above the arm of the second Theophilus, and the left wing below the arm of his [recumbent] counterpart, the variation corresponds to the interplay of the mantle and the arm in the two figures. At the right, Theophilus' left arm issues from under the mantle; in the upper figure the corresponding right arm extends above the mantle." This, in turn, then leads to further permutations and connections: "Finally, the praying Theophilus . . . appears to be an arched form spanning the first and the second Devil and surmounting the first Theophilus, as if the latter were a central figure. The two Devils are bound in turn by the embracing mass of the penitent, just as the wing in the first scene connects the heads of the Devil and Theophilus."[28]

FIGURE 4. *Trumeau detail, church of Sainte Marie, Souillac, France, photograph courtesy of A. Allemand.*

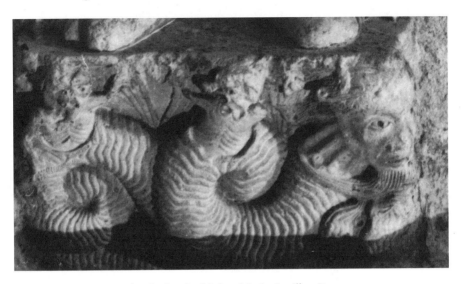

FIGURE 5. *Tympanum detail, church of Sainte Marie, Souillac, France, photograph courtesy of A. Allemand.*

This is by no means the end to these chains of correspondence, which continually evoke reminders of the stably imposed orders usual in other Romanesque tympana, only to destabilize those provisional symmetries with congruent but competing ones. One can begin at almost any point in the composition and these proliferating correspondences will in the end encompass the entirety of the composition, so that each element retrospectively encapsulates the logic of the whole.

.

It is only after having spent two-thirds of his text establishing this internal logic and thus generating an intricate narrative from his basic visual oppositions that Schapiro even bothers to relate the received legend of Theophilus—and even that account is fragmentary. Something else has come into being that exceeds theological precedent and can have as its reference only a far larger set of relationships in the social dynamic of the region in the early twelfth century: "The antitheses of rank and privation, of the Devil and the Virgin, of apostasy and repentance, create a psychological depth—the counterpart of a world

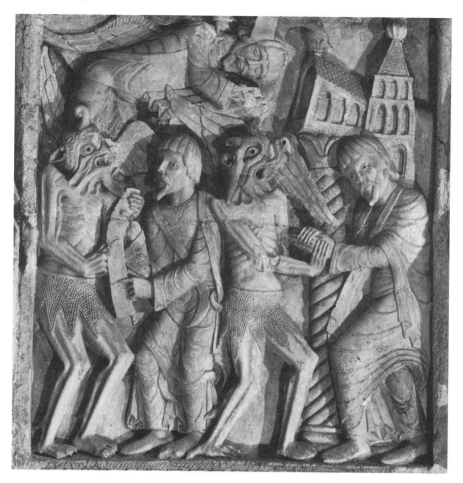

FIGURE 6. *Tympanum detail, church of Sainte Marie, Souillac, France, photograph courtesy of A. Allemand.*

of developing secular activity and freedom, more complex than the closed world of Christian piety represented in dogmatic images of the majestic Christ."[29] The monument demands a social history, but that history finds its place only at the end of an intricate dissection of internal oppositions and must be sustained within that symbolic armature: Schapiro's mode of analysis—and the choice of object that permitted it—opened art-historical interpretation to realistic information about the Middle Ages, even if comparatively little was known at that point concerning the local history of medieval Souillac (to this

day, historical understanding has been impeded by the loss of nearly all of the abbey's archives).[30]

Knowing at least that the abbey held feudal sovereignty over the town, that the startling revival of monumental stone sculpture in the area depended on the talents of secular artists (as opposed to the monks responsible for figurative painting in manuscript illumination) sustained Schapiro's formal deductions that the Church, through these permutations of Christian art, did "not simply reaffirm its older doctrines" but isolated "the aspects of these themes relevant to its mediating function, its power, and its interests in the changing society of which the church is a sensitive part."[31] An adequate understanding of the inner logic of a work of art—articulated through differences neither strictly thematic nor strictly formal but both at once—was enough to expose the inadequacy of the prevailing, ideologically blinkered version of medieval life.

One can go further and say that this drive to expand the range of reference for medieval art, derived from the analysis of a single monument, exponentially raised the level of ambition in interpretation. The prevailing account of Romanesque style had followed an isomorphism between form, society, and belief: As the social order held the individual in a position determined by birth and prescribed by divine ordinance, so the human figure in art was consistently made to conform to the superior dictates of the architectural frame; symmetry and centrality were its key organizing principles. Schapiro did not so much deny that assumption as turn it inside out: Instead of proceeding from examples that are statistically most prevalent and then defining everything else as peripheral or exceptional, he began by analyzing what happens when the usual, reassuring regularities of form disintegrate; then the true power of an art system could begin to be comprehended. It was no longer accounting for this one instance as like or unlike a norm; it was to posit something near the totality of what Romanesque could encompass in its cognitive and emotive charge and do so from a single instance.[32]

Taking a bold further step, Schapiro was pursuing nothing less than a diagnosis of art's fundamental signifying capacities, a dissolution of

the conventional dichotomy of form and content. The key to that achievement appears to have been identifying an object that already enacts the disturbance necessary to interpretation, both in its "disco-ordinate" internal arrangements of motifs and in its eccentric relation to the larger body of related objects: These traits become the condition for maximum intelligibility in a work of art. And the thread was picked up shortly afterward—and extended into new realms of subject matter and of theoretical reflection—by an intellectual figure experiencing a deeper, more frightening form of alienation. The next chapter will take as its central topic the epiphany experienced by the French anthropologist Claude Lévi-Strauss, exiled in 1943 to Schapiro's New York, the experience that ultimately made him an art historian.

2 A Forest of Symbols in Wartime New York

Meyer Schapiro brought his youthful commitments to medieval scholarship, contemporary art, and left-wing political activism to a culminating synthesis in the years around 1940. That success bore all the marks of a state something like internal exile in relation to the social, intellectual, and institutional protocols of his chosen discipline. The years that followed visited the condition of manifest, external exile on an extraordinary group of thinkers and artists who suddenly came to surround Schapiro in his native city. One of these, the young French anthropologist Claude Lévi-Strauss, so tellingly took up the unfinished business of "The Sculptures of Souillac" that he can serve as a rare example of an interdisciplinary visitor to art history who genuinely advanced his adopted field.

In contrast to Walter Benjamin's unhappy fate, Lévi-Strauss had successfully escaped the persecution of Jews in occupied France, arriving in New York in 1941 after a prolonged, risky voyage from Marseille via Martinique and Puerto Rico.[1] Once established there, he duly came into the kind of fellowship that Schapiro had promised the resistant Benjamin: His most decisive encounter came with another refugee, the Russian-born linguist Roman Jakobson, who had found his way to New York in the same year, taking a teaching post at Columbia, where, of course, he immediately attracted Schapiro's curiosity. Indeed Jakobson would have been among the most capable people anywhere to understand the underlying logic of the Souillac article; but the stimulus of his thinking bore most directly and immediately upon Lévi-Strauss.

The occasion was a series of lectures on phonology that Jakobson gave in his status as professor conferred by the École Libre des Hautes Études, an academy in exile formed by French and Belgian refugee

scholars and housed in the New School for Social Research in down-town Manhattan. Given the central—if not founding—role that Lévi-Strauss played in the so-called linguistic turn in the human sciences, it is startling to read him recalling that "at that time I knew almost noth-ing about linguistics and Jakobson's name was not familiar to me."[2] As a colleague in the École Libre, he had come along hoping for no more than some technical points in recording exotic languages; what he found, by his own testimony, was the key to all of his subsequent investigations into kinship systems, totemism, mythography—and, eventually, visual art.

Earlier students of phonology, Jakobson argued, had foundered in attempting to account for myriad local developments in the produc-tion of sounds, but in so doing had entirely missed the point at which sound and meaning are joined. His simple but decisive shift in focus was away from the positive substance of sounds and toward the pat-tern of differences between them. Each phoneme, as he defined them, carries no meaning in itself, but all meaning attached to larger units— roots, prefixes, suffixes, whole words, sentences—depends upon *"its power to distinguish the word containing the phoneme from any words, which, similar in all other aspects, contain some other phoneme."*[3] (These words appear in italics in his prepared text and must have been deliv-ered with heavy emphasis.)

His simple but decisive shift in focus was away from the positive substance of sounds and toward the pattern of differences between them. Lévi-Strauss gives this concept—the core of the "structuralist" point of view—a pithy summation in a tribute to Jakobson: "[P]ho-nemes perform their function not by virtue of their phonic individu-ality but by virtue of their reciprocal oppositions within a system."[4] And, for him, this revelation was sufficient to reorientate his entire project as an anthropologist. Henceforth, his personal fieldwork in South America, undertaken during the 1930s, was to form only part of a globally comparative field, across which he could deploy credible data from any anthropological source—and let the developing logic of the system sort them out. He found that logic in the prohibition against incest, some form of which exists in every known human soci-

ety. Existence and meaning, nature and culture, joined at that point, which was no more than a differentiating mark placed on biologically interchangeable individuals: this one you may marry; that one you are forbidden to marry. Because family units must therefore exchange their children to make good marriages, the reciprocity and mutual obligation that define social life is perpetually secured at all levels, both practical and symbolic.

As with human languages, a starkly simple principle can generate kinship systems of nearly endless variation and degrees of complexity: precisely the real-world outcome that he believed had defeated previous anthropological interpreters. His diagnosis of the problem anticipates the general difficulties with art-historical interpretation sketched in the previous chapter: "[T]hey had still not risen above focusing their attention on the terms, to look rather at the relations between them . . . and were therefore condemned to the endless task of searching for things behind things in the vain hope of reaching something more manageable than the empirical data with which their analyses had to cope."[5]

.

In his rented rooms in Greenwich Village, not far from Schapiro's own residence, Lévi-Strauss set about correcting that deficiency, translating his luxuriance of examples to a large but nonetheless delimited and manageable set of relations between terms, that is to say, between possible positions within networks of clan or familial bonds. The result, published five years later, was the daunting edifice of his *Elementary Structures of Kinship*. But his thoughts were far from exclusively occupied by its lofty abstractions of human social organization. He has written only one brief memoir of his first years of exile in America, entitled "New York in 1941," but it is curious to read the extent to which he reduces the city to an emporium for objects from the most diverse cultures—and of the highest aesthetic standard—that the dislocation of wartime sent pouring into the dealer's closets and humble antique shops of the city. And their cost in those days did not exceed a refugee's resources: "[W]hoever wanted to go hunting

needed only a little culture and a little flair for doorways to open in the wall of industrial culture."[6] The Surrealist overtones of that remark testify to his friendship in those years with André Breton, who lived nearby (and was likewise befriended by Schapiro). Together they treated the storefronts of New York as the same gateway to the marvelous that Breton and his first circle of Surrealists had found in the Paris flea market of the 1920s. That former ideal of collective endeavor, however, appears to have given way to possessive individualism, as "fierce competition" broke out "among those who are not willing to live in a world without friendly shadows or secret shortcuts known only to a few initiates."[7]

Fortunately, many more of these "friendly shadows" resided in a precinct open to everyone. "There is in New York," Lévi Strauss wrote in a 1943 essay, "a magic place where the dreams of childhood hold their rendez-vous; where ancient tree trunks sing and speak; where indefinable objects watch out for the visitor with the anxious fixity of human faces."[8] This place of enchantment lay inside the American Museum of Natural History, in its hall devoted to the indigenous peoples of the north Pacific coast of North America (fig. 7), though Lévi-Strauss's vocabulary harks back to an earlier moment in the advanced art of France, specifically the celebrated opening lines to Charles Baudelaire's poem "Correspondences":

> Nature's a temple where living pillars
> Make their mingled voices faintly heard.
> Through forests of symbols walks man
> Watched over by familiar eyes.[9]

The thoughts here are complicated, to say the least. Not only the occult overtones of the verse but also Baudelaire's status as the national poet of urban estrangement confer a paradoxical aura of home and recognition on the place. But it was also a home in a more prosaic, professional sense. The author of the installation was the elder statesman—indeed the virtual founder—of American anthropology, Franz Boas. What was more, the career and personal commitments of this

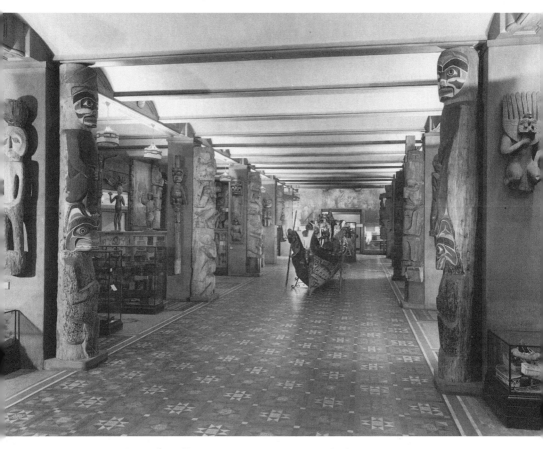

FIGURE 7. *North Pacific Hall, 1943, courtesy Department of Library Services, American Museum of Natural History, no. 318913.*

fellow Jewish scholar anticipated, albeit voluntarily, the trajectory that Lévi-Strauss had lately followed. Boas was likewise a European who had found his professional and intellectual vocation in the New World. A Prussian geographical expedition to the arctic territory of the Baffin Island Inuit people had inspired his vocation for the nascent study of anthropology, which then had yet to cohere as an autonomous intellectual discipline. Early experience of German anti-Semitism convinced him that his ambitions would always be frustrated at home; the liberal inheritance of his family, partisans of the revolutions of 1848, made him hostile to Wilhelmine autocracy and imperialism.[10] Both prompted him to emigrate and make his career in America. His appointment to

a professorship at Columbia University in 1899 effectively secured traditional academic standing for his field, and he used that base to train more than one generation of its leading American practitioners (one of his more occasional students was the young Schapiro).

Before his Columbia appointment, he had pursued his first campaigns of research among the Kwakiutl of Vancouver Island under museum auspices—the usual arrangement of the time; until 1905, he oversaw the Northwest Coast collection in the American Museum of Natural History. There, he found himself in almost immediate conflict with amateur anthropologists, many drawn from the WASP ascendancy, holding key positions in the national museums and civil service. At issue was the reigning, evolutionary perspective, in which any artifact was placed on a hierarchical ladder leading from the most rudimentary cultural level to the pinnacle of white Euro-American civilization. Behind this assumption of inferior and superior cultures lay the supposition that there were inferior and superior races. The apparently practical matter of arranging the Northwest Coast objects in the museum embodied Boas's protest against this regime of thought.[11]

His chosen mode of display in the North Pacific Hall (fig. 8) contradicted the usual practice of grouping types of artifacts together to compare levels of development. Instead each alcove was devoted to a single ethnic group, Boas having more or less founded our own modern understanding of culture as meaning a total way of life; no item from that culture was comprehensible or open to judgment as to its fitness apart from the web of relationships in which it was embedded.[12] As a manifestation of that commitment, the North Pacific Hall remains substantially as Boas first conceived it at the turn of the century and more or less as Lévi-Strauss first saw it more than a half century ago (fig. 8). Descending to the basement and finding a path behind the exotic animal dioramas, one turns a corner to find nearly a century of museological updating fall away: The totem poles that punctuate the alcoves still seem to support the temple of Baudelaire's imagination. In their poorly lit recesses, vividly figurated masks, decorated boxes, costumes, tools, and utensils make the mingled, calling voices palpable. The survival of Boas's earnest program, as Lévi-

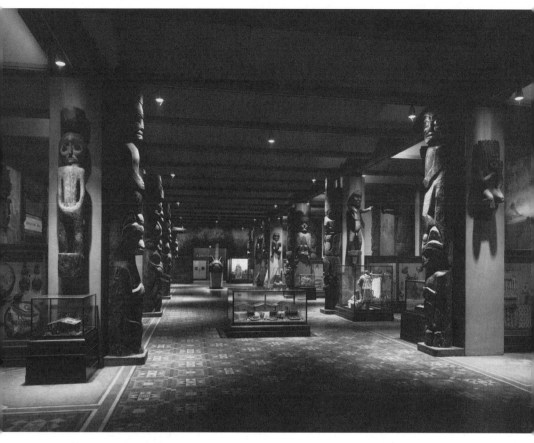

FIGURE 8. *North Pacific Hall, 1962, courtesy Department of Library Services, American Museum of Natural History, no. 328715.*

Strauss saw it, "conferred the additional allurements of the chiaroscuro of caves and the tottering heaps of lost treasures, which may be seen daily from ten to five o'clock."[13]

Already by the 1940s, the obsolescence of the display had turned what should have been a transparently public experience into an occasion of private fascination and longing. Lévi-Strauss did not imagine that it would last, assuming that the most obvious alternative construct—that of cultivated visual art—would take over: "Surely it will not be long before we see the collections from this part of the world moved from the ethnographic to fine arts museums, . . . for this art is not unequal to the greatest, and, in the course of the century and a half

of its history that is known to us, it has shown evidence of a superior diversity and has demonstrated apparently inexhaustible talents for renewal."[14] While he obviously felt that this move would constitute a gain in the dignity and quality of attention accorded these objects, he was by no means blind to the partial nature of the compliment thus conferred upon them. In their capacity, as he saw it, to join the contemplative serenity of the sculpted portal figures at Chartres cathedral with the rude artifices of carnival, they revealed the inadequacy of any existing context of apperception to contain them. In awe at "this dithyrambic gift for synthesis, this quasi-monstrous ability to perceive the similarity between things that others regard as different," the displaced French anthropologist felt simultaneously transported "from Egypt to twelfth-century France, from the Sassanids to the carousels of suburban amusement parks, from the palace of Versailles (with its insolent emphasis on crests and trophies . . .) to the forests of the Congo."[15]

Within the established world of the fine arts, perhaps only Schapiro would have seen this dissolving of boundaries as cause for celebration. Nor would many in that world, at least beyond the exiled Surrealist community, have welcomed his view that this awe-inspiring imaginative reach was actually a reproach to the creative capacities of the category-bound West, all the more so for having arisen from what Lévi-Strauss romantically termed a "rosary of villages strewn along the coast and the islands," whose inhabitants numbered only between 100,000 and 150,000 souls, "an absurdly low figure when one considers that the intensity of expression and important lessons of this art were worked out in their entirety in this remote province of the New World by a population whose density varied from one to three tenths of a person per square kilometer."[16] European culture, in his view, was the lesser in that it depended on isolated individuals—out of all of its millions—to manifest the creative capacity held in common by this entire archipelago of Native American groupings, whose artists, it seemed, produced almost nothing that lacked a common genius: "[T]his unceasing renewal, this inventive assuredness that guarantees success wherever it is applied, this scorn for the beaten track pushing

ever new improvisations which infallibly lead to dazzling results—to grasp the idea of them, our contemporaries had to await the exceptional genius of a Picasso."[17] How much greater the achievement, he was asking, when such freedom of invention could spread everywhere in a culture rather than being monopolized by a few feted and over-rewarded individuals?

.

In weighing these words, due allowance must be made for more than a little romantic idealization, political utopianism, and proselytizing zeal. There was doubtless a deep connection between the peril to Lévi-Strauss's French inheritance (perhaps gone forever; who knew in 1943?) and this discovery of a magical substitute and source of solace, a cultural flowering that seemed both to awaken his childhood memories and assuage the loss of the great monuments of Europe (among those he specifically mentions is twelfth-century church portal sculpture). And for many years, his attention to visual art largely remained in this realm of excess in relation to the rigors of his inquiries into other social phenomena.

The 1960s, however, saw his production, beginning with *The Raw and the Cooked*, of the four-volume *Mythologiques*.[18] In that monumental enterprise, he attempted to discern logical shape within the overwhelming narrative variety of Native American myth from both the Northern and Southern Hemispheres. In so doing he necessarily had to subdue a seeming riot of thematic material, comparable in its imaginative brilliance to the Northwest Coast objects that had so captivated him twenty years before—in effect, to impose upon it the discipline of Jakobson's analytical framework. And, like Jakobson, he shifted the center of mythological studies from the motifs themselves to the logic of the relationships between them. The most recurrent motifs, for him, took on fundamental differential value within a system; and these he designated "mythemes." To grasp that differential value, the investigator had to set aside the ordinary denotation carried by any key term; the common-sense meaning of sun, rainbow, jaguar, salmon, honey, spouse, or child was at best secondary: "[I]ts meaning

could only be identified from the relations of correlation and opposition in which it stands to other mythemes" within the particular narrative in which it plays a part. In the minds of indigenous speaker and audience, these units exist in an implied array of possible terms, their positions defined by opposed pairs of elementary qualities: high/low; wet/dry; close/distant; dark/light—or, indeed, raw/cooked. This grid, as Lévi-Strauss explained in his homage to Jakobson, "confers a meaning not on the myth itself but on everything else: i.e., on the picture they have of the world, on society and its history about which the group members might be more or less accurately informed, and on the ways in which these things are problematic for them. Normally these diverse facts fail to hang together and more often than not they clash with one another. The matrix of intelligibility provided by the myth allows them to be connected into a coherent whole."[19]

As was brought out in Chapter 1, Schapiro had deployed, in an ad hoc way, a similarly basic array of conceptual oppositions to chart the operations implicit in the Souillac portal sculpture; and the hypothesis that he offered in conclusion suggests that its arrangements provided just such a "matrix of intelligibility" for the place of belief and the established church in the midst of stressful, contradictory circumstances. Lévi-Strauss, by the end of the 1960s, possessed the overarching theory that Schapiro had lacked. In that he had rendered the temporal flow of myth into spatial arrangements of concepts, it was almost axiomatic that the masks of the Northwest Coast could be configured within the same logic: They were prized heirlooms and status markers within lineages; the masks were bound up with their own myths of origin; crucial expressions of group solidarity and continuity depended upon their appearance (in both active and passive senses).

Nonetheless, for all the resources of grand theory and system building at his command, the anthropologist needed the sort of ad hoc entry into the visual realm that Souillac had given Schapiro. Exactly when he found it is difficult to know, but it was only in 1975, with his publication of *The Way of the Masks*, that he fully returned to the convergence of intellectual and sensory revelation that had overtaken him during his New York exile. The French title of his book, *La Voie des*

masques, means, literally, way or path, but it also carries a serious pun on "voix," so it sounds to the ear also like the "voice" of the masks. The path in question was certainly one of Lévi-Strauss's own enlightenment—the word is not too strong; the calling voice lay within the objects themselves. But his renewed evocation of Baudelaire's living pillars carries more than emotional and autobiographical overtones. The voices ascribed to the objects refer just as much to recognitions within the observer, not all of them fully present to conscious reflection. In the terms being developed here, the "voice" is some empirical feature of the phenomenon under scrutiny that in and of itself provides the key tool for analysis and understanding. Its first faint recognition is likely to strike the interpreter with the mingled, muffled effect of Baudelaire's spirit chorus.

.

If Schapiro's attention to Souillac offers a guide in this, one should look away from the obvious center of any highly developed artistic complex and instead concentrate on more marginal, seemingly incomplete examples, where stable orders seem to come unstuck. There the processes of artistic thought are more likely to attain a certain visibility. Consistent with this hypothesis, the signal that Lévi-Strauss required did not come from the florid richness of form and motif that dominated his view in the early 1940s. Then he had singled out for praise the work of the Tlingit, "to whom we owe sculptures of subtle and poetic inspiration," and the Kwakiutl, "with their unbridled imagination" and "stupefying orgy of form and color." Instead, in beginning his full study of the art some three decades later, he sets these elaborate cultural refinements aside and settles upon an object from the southernmost group, the Salish, whose arts he had called only "much simplified . . . angular and schematic."[20]

For Lévi-Strauss to gravitate toward the Salish was to opt for the periphery as opposed to the heartland within this complex of cultures; and by fixing onto an object that defeats modern-day, intuitive expectations of aesthetic regularity, he opened himself, as far as possible, to another set of expectations. Of the masks called *Swaihwé* (plate 1), on

which he fixes as the key to his entire project, he states bluntly, "their plastic logic escaped me."[21] Their typical outline seemed wildly out of balance, a heavy upper mass overhanging a grooved vertical appendage, leaving a narrow, squared-off base, "as if the design had been sawn off in mid-course." And that formal anomaly was accompanied by equivalent thematic oddities. He asks, "Why the gaping mouth, the flabby lower jaw exhibiting the enormous tongue (for that was what the lower feature stood for)? Why the bird heads which have no obvious connection to the rest and are most incongruously placed? Why the protruding eyes, which are the unvarying trait of all the types? Finally, why the almost demoniacal style, which resembles nothing in the neighboring cultures or even in the one that gave it birth?"

In posing these questions he was exceeding the norms of his home discipline: From an orthodox anthropological point of view, no artifact that successfully occupies a functional niche within a culture can be said to be inadequate; it is enough that it be consistently marked in its distinctive features—as the *Swaihwé* most certainly is. But Lévi-Strauss nonetheless asserts, intuitively but insistently, that this object remains unrealized, marked by a deficiency, faltering in comparison to the coherent rhetoric that prevailed among the neighboring Kwakiutl, who borrowed the mask type from the Salish but gave their version the heightened, expressive naturalism that marks their other human and animal representations.

His first step in reconciling this object with the wider repertoire of Northwest Coast objects is a comprehensive inventory of its features, first in terms of its formal consistencies from example to example and also against other sets of markers, those provided by the personage it represents in rituals and by the myths supplied by the Salish to explain how the mask came to them. Alongside the motifs of gaping tongue, protruding eyes, and bird heads, he notes a further avian association in the frequent use of white swan feathers and down in the surrounding costume (fig. 9). On the social level, possession of or assistance from the masks was believed to favor the acquisition of wealth; they appeared at profane ceremonies of marriage and death (fig. 10) rather than at the sacred winter rites; they belonged only to a few noble

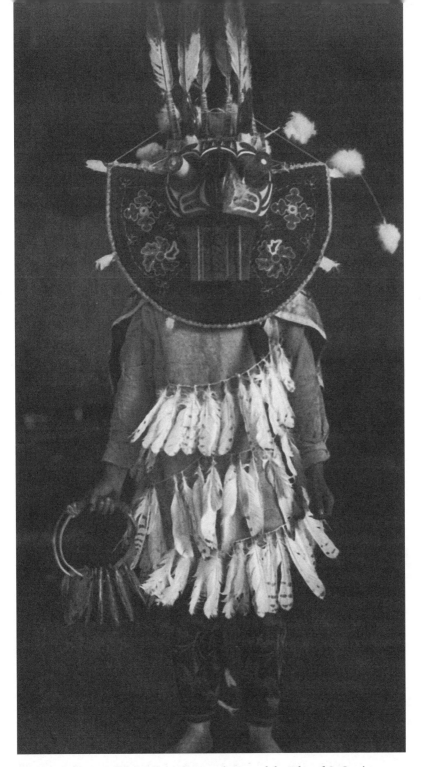

FIGURE 9. *Coast Salish* Swaihwé *dancer, photograph by Edward S. Curtis, Special Collections, University of Washington Libraries, neg. no.* NA282.

families and were passed on only by marriage and death. The myths describe them as the images of the supernatural ancestors of these highest-ranking lineages, and the stories of their origins further bring out a clear affinity between the masks and fish, in that humans acquire the masks by first fishing them from the sea and that sometimes the pendulous tongue is carved as a fish. So much seems intuitively likely from the form, but the other consistent association is not: The mineral copper parallels the masks, being discovered in the same fishing procedure or being disseminated through the same kind of marriage exchanges. "Is it possible," Lévi-Strauss asks, "to understand these scattered traits and to articulate them into a system?"[22]

.

If the interpreter stays only within the ritual and mythic system of the Salish alone, the answer would be no. The Salish mask is frozen into this form by other, unseen configurations that extend its network of significance much further. The American Northwest Coast provides the analyst with an extraordinary laboratory for studying systems of formal transformation in that the various native communities carried on a high, constant level of communication and exchange. The overwhelming natural abundance of the coastline, with its tiny population, made for much exchangeable wealth; a fiercely hierarchical social order with an abject slave population gave the highborn the leisured curiosity to develop one of the world's great complexes of material symbols. Thus did a highly interconnected cultural system come about, one strong enough to cut freely across three distinct language families spoken in the region.

An analysis of the derivation of origin myths allows Lévi-Strauss to confirm oral traditions that the *Swaihwé*, which had its origins in Coast Salish groups on the mainland, only later passed to their ethnic counterparts on Vancouver Island (the Comox group). That transfer brought the mask into the powerful orbit of the Kwakiutl and other Kwak'wala-speaking tribes,[23] who took it up for their own uses (plate 2). They gave it the cognate name *Xwéxwé* (or *Xwixwi*) and reproduced the bulging eyes, bird heads, and protruding tongue, though, as he

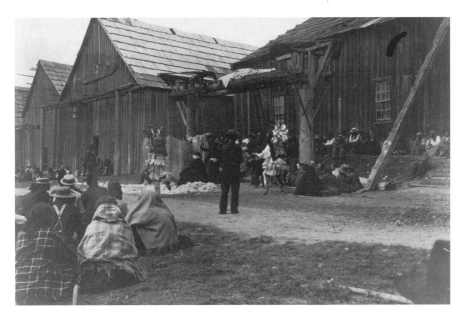

FIGURE 10. *A* Swaihwé *dance, early twentieth century,*
Royal British Columbia Museum, PN *5894.*

puts it, "transposed into a style that is less hieratic, more lyrical, and
more violent."[24] As with the Salish, the *Xwéxwé* appears at ceremonies
marking life transitions: marriage, death, inheritance; it especially fa-
cilitates the beneficial transfer of wealth from a bride's family to her
husband's and ensures the perpetuation of sound lineages. But be-
tween the two groups the two masks have come to assume opposite
characters. Instead of fostering wealth for those who have the right to
wear them (as among the Salish), the Kwakiutl *Xwéxwé* acts as a rude
clown who interferes with the children scrambling after the coins
flung into the crowd by other maskers. This character of the selfish
egotist is in fact one that the Salish attributed to all human beings
until the gift of the *Swaihwé* from a supernatural source lifted them
into cooperation and prosperity.

Though Lévi-Strauss does not mark this in any explicit way, the
Salish version distills the very principle of the incest prohibition into
a portable, manipulable object. But the opposed functions of the
Kwakiutl cognate make it plain that the iconographic traits of *Swaihwé*

—tongue, birds, bulging eyes, etc.—only carry this deep meaning on a local or contingent basis. Do the Kwakiutl therefore lack such a deep signifier of their own? They do not, and their own mythic and ritual guarantor of wealth and good lineages precisely mirrors the *Swaihwé* in the set of relations it embodies; but each salient trait on one mask is the absolute reverse of the other. Lévi-Strauss in fact arrives at the form of this Kwakiutl benefactor through a deductive thought-experiment before acknowledging the existence of the actual artifact:

> Through its accessories and accompanying costume, the Swaihwé mask manifests an affinity for the color white. The opposite mask will therefore be black, or will manifest an affinity for dark hues. The Swaihwé and its costume are adorned with feathers; the trimmings of the other mask should be in the nature of fur. The Swaihwé mask has protruding eyes; the other's eyes will have the opposite characteristic. The Swaihwé mask has a wide-open mouth, a sagging lower jaw, and exhibits an enormous tongue; in the other type, the shape of the mouth should not allow the tongue to be visible.[25]

The result of these permutations, he then reveals, amounts to a precise mapping of a key Kwakiutl mask and mythological personage called *Dzonokwa* (plate 3).

This character is a female giant, covered in a black pelt, who is said to inhabit the deep woodlands of the mainland interior. As a masked dancer, she takes part in the sacred winter rites from which, as noted above, the Salish exclude the *Swaihwé*. Where the original *Swaihwé* beings were fished from below, the *Dzonokwas* must be pursued horizontally over land (she steals fish from humans and kidnaps children, whom she carries to her forest fastness). But the two masks nonetheless have one powerful trait in common: a positive affinity to the mineral copper and its consequent bestowing of wealth and prosperity. Heroes who encounter her gain the fabulous wealth that she controls, either by her gift or by killing her (her great weakness is that she is nearly blind—and indeed tries to blind her opponents or the children she steals).

Both *Swaihwé* and *Dzonokwa* thus stand in shared opposition to the stingy nature of the Kwakiutl *Xwéxwé*, though the logic of the relation between the three masks remains unresolved until Lévi-Strauss calls attention to yet another object, a fourth term that belongs to another category altogether and one, moreover, that was distributed widely through the region. This is the "Copper," a spade-shaped object fashioned from that metal, which represents the greatest wealth (which is saying a great deal) among the Kwakiutl and the other groups to the north as far as southeastern Alaska (fig. 11). Only aristocrats in possession of great wealth owned them, and no one individual could lay claim to more than a few: They were far and away the most valuable single objects in existence within these societies.

Their configuration is invariant: a surmounting crest shape with a narrower, raised base completed by a descending vertical rectangle divided by a central ridge. A Copper acquired its value exclusively through the ceremonies of the potlatch, the feast and ostentatious bestowing of gifts that had to accompany marriage, accession to new rank, or funerals among the aristocracy. During the funerary potlatches of the more northerly Tlingit, a Copper might be broken into bits and distributed to the guests as the "bones" of the deceased; in former times, the breaking was accomplished with the same club used to execute slaves in an equivalent sacrifice of wealth.[26] A Copper could likewise face complete extinction, thrown into the fire or ritually "drowned" in the sea as one of the most expansive gestures of honor a host could perform.[27]

Among the Kwakiutl, the equation with human life was not so brutal; in the postcontact period, potlatch gifts came to be precisely calibrated in the currency of trade goods, chiefly the woolen blankets that cost between 50 cents and $1.50 in nineteenth-century values (many times greater today). Potlatch obligations increased geometrically as a male individual acceded to the various names and titles owed him at birth or ceded by marriage. The peak exchange value of a Copper could reach into the tens of thousands of blankets, and such legendary items acquired mighty names of their own. One magnanimous potlatch gift was to cut bits away from a Copper (fig. 12), and this could

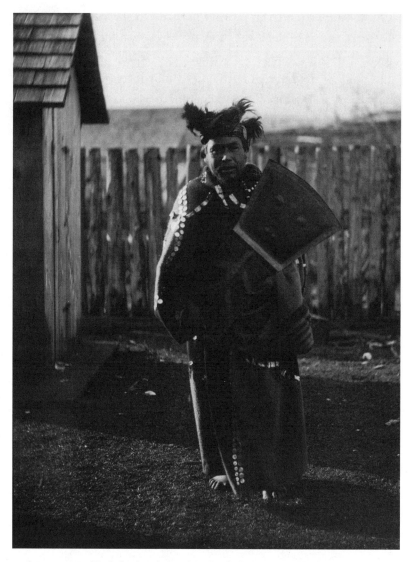

FIGURE 11. *Kwakiutl chief Wakgas of Koskimos holding a Copper, 1894, photograph by O. C. Hastings, courtesy Department of Library Services, American Museum of Natural History, no. 11577.*

go on until only the ridge and spine were left; yet even these retained much of their previous exchange value in blankets.[28]

In Lévi-Strauss's analysis, the completion of the circle comes with the recognition that the Coppers used by the Kwakiutl and the *Swaihwé* mask of the Salish share the same shape. The *Swaihwé* is, in effect, the

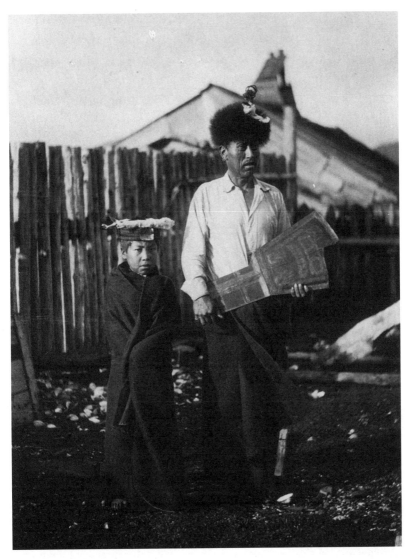

FIGURE 12. *Kwakiutl chief Tutlidi giving away Copper in honor of his son, 1894, courtesy Department of Library Services, American Museum of Natural History, no. 106707.*

wooden representation of a Copper, transformed overtly into a super-natural being and put into movement in the costume and actions of the dancer (fig. 13). Or conversely, he suggests, the form of the Copper may have been a distant echoing of the *Swaihwé*, a more ancient bor-rowing whereby the Kwakiutl and the northern groups materialized

its conceptual essence as wealth and the successful perpetuation of a lineage. Whatever the source of the Copper shape, its presence among the Kwakiutl blocked any straightforward borrowing of the *Swaihwé*. They already possessed the shape, so that element was effectively subtracted, leaving the Salish mask split into two components. The figurative components—eyes, birds, tongue—were grafted onto a standard facial type, yielding the *Xwéxwé*. The greater flamboyance of their sculptural tradition yields a wider and more spectacular set of variations, but the retention of the key features of the Salish prototype entails a reversal of the meaning of the mask, which assumes a relatively trivial, subsidiary role in the potlatch.

The token opposition of the weak *Xwéxwé* could, of course, only be interesting as an enhancement to a much stronger entity. Among the Kwakiutl, a masker wearing the face of *Dzonokwa* carried the Coppers during the potlatch; and when the host gave them away or broke them into pieces, he donned a more impressive *Dzonokwa* mask of his own.[29] Thus, where the Kwakiutl preserved the meaning of the *Swaihwé*, that is, where they created an equally strong supernatural bearer of Coppers, the form was entirely reversed: black for white, fur for feathers, female for male, recessed eyes for goggling ones, pursed mouth for gaping maw. Though a typical example is full of the expressive intensity and technical polish so characteristic of Kwakiutl sculpture (fig. 14), it is in fact just as incomplete as the schematic and unbalanced *Swaihwé*, which is its conceptual twin. Each remains unintelligible without the implicit presence of the other, and both rely for their meaning on a system larger than any one local society.

The traits of the *Dzonokwa* as related in myth underwent a parallel reversal: Its home, at a far distance on land, replaced the origins of the *Swaihwé* at great depth in water; its thieving ferocity replaced generous benevolence; its blindness replaced dazzled vision. But it would be a mistake to regard the visual aspect of *Dzonokwa* as an illustration of the character as she appears in myth: Both are rather the same cluster of traits rendered through different means, myth being a rendering of the cluster in the form of narrative, the mask being its rendering as a plastic array. It would be as likely that the myth was evolved later as a

secondary rationalization of the logically necessary elements of the mask: This is to say, having reversed the stalk eyes of the *Swaihwé*, the idea of blindness suggests itself, and a narrative of *Dzonokwa*'s poor eyesight might logically follow.

Such temporal sequences remain impossible to verify, there being no necessary priority to either narrative or sculpture. The meaning of both is lodged in a cluster of traits defined by abstract mental oppositions: in versus out, open versus closed, upper versus lower, dark versus light, wet versus dry, and so on. The rule of this oppositional logic allows Lévi-Strauss to propose a theorem predicting the behavior of forms—both sculptural and mythic—as they cross cultural barriers: If the meaning is preserved, the traits will reverse themselves, as in the inside-out transformation of *Swaihwé* into *Dzonokwa*; on the other hand, if the form is preserved, as in the borrowed *Xwéxwé*, then the meaning is reversed.

.

In order to gauge the possible wider application of this rule, was there not a similar process implied in Schapiro's analysis of the fabulous trumeau at Souillac? Across the wider territory of southwestern France, church portal sculpture in the same period invariably placed, as at the abbey church of Moissac, an enthroned Christ in majesty at the center of the tympanum (fig. 15). A customary feature of that image from the Last Judgment, following the text of the book of Revelation, was a surrounding retinue of four adoring beasts (over time conflated with symbols for the four evangelists). By contrast, the center of the tympanum at Souillac is famously preempted by a scene of the Devil and his temporary corruption of the mortal Theophilus, the presence of the diabolical and the mortal at the elevated center of the sculptural complex thereby blocking the adoring beasts from taking up their customary places.

But something like a conservation of matter prevails in the repertoire of apocalyptic themes: The beasts do not go away; displaced from their usual place, they migrate to the lower zone of the portal, colonize the trumeau, and are thereby transformed from benign at-

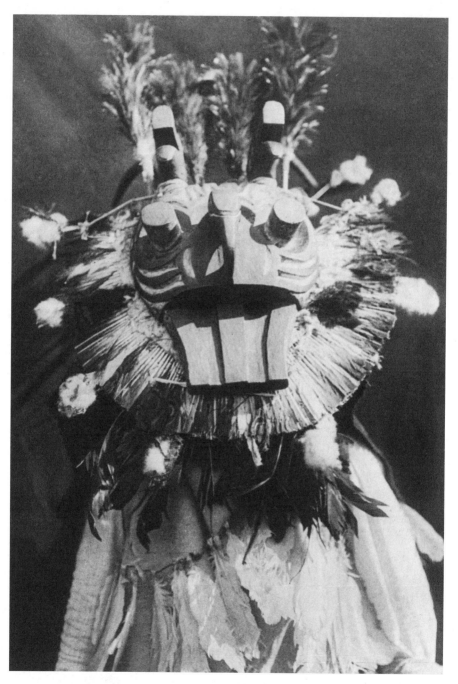

FIGURE 13. Swaihwé *mask, Cowichan (Coast Salish), British Columbia, wood, pigment, and feathers, photograph by Edward S. Curtis, Special Collections, University of Washington Libraries, neg. no. NA283.*

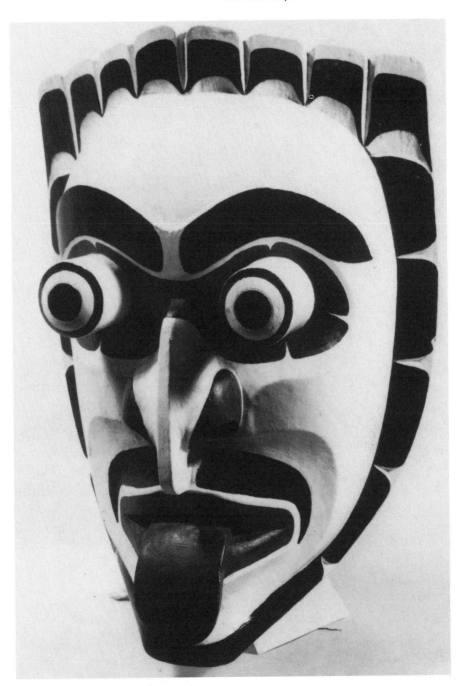

FIGURE 14. Xwéxwé *mask, Kwakiutl, British Columbia, wood and pigment, courtesy of the Museum of Anthropology, University of British Columbia, Vancouver, Canada.*

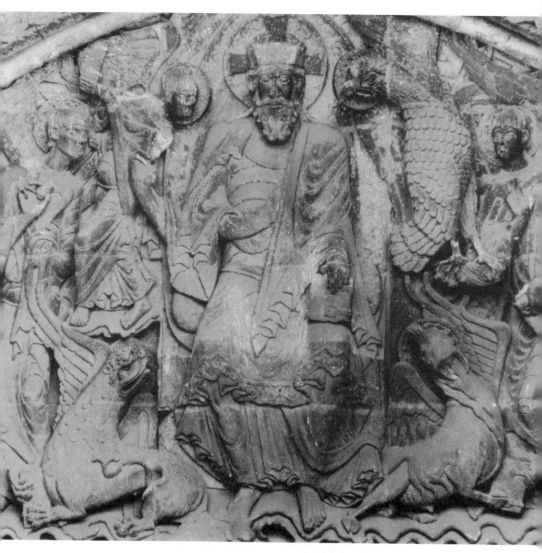

FIGURE 15. *Tympanum, detail of Christ in majesty with the symbols of the evangelists, Church of St. Pierre, Moissac, photograph by David Finn, in Meyer Schapiro,* The Sculpture of Moissac.

tendants into that fantasy of unbridled menace and predation that Schapiro so eloquently describes (with the biblical beast that bears the head of a man perhaps assuming the role of victim at the top). In this process, they lose strictly dogmatic sanction, slipping out from the usual categories of iconographical understanding (though they none-

theless retain in their new position and function the aura of Christ's servants and the authority of a place in the divine plan). The scriptural text, which appears to explain more orthodox portals, remains prior but ceases directly to govern the choice and disposition of symbolic motifs.[30] Once the system is seen as a whole, the orderly appearance of the portal at Moissac requires for the completion of its meaning the discoordinate composition of Souillac, just as the *Dzonokwa* requires and presupposes the *Swaihwé*.

In this respect, Schapiro may have been wrong to lay such stress upon the fantastic elaboration of the Souillac trumeau as a product of artistic improvisation on the part of the lay stone carvers. Conversely, Lévi-Strauss may have expressed his transformative principle in terms that are too rigid—or perhaps did not sufficiently refine his own principle. He states categorically, "Except for stylistic differences, all the plastic characteristics of the Swaihwé are found in the Xwéxwé of the Kwakiutl," that continuity being permitted by the reversal of meaning between them. But that qualifying "except for stylistic differences" surely is asked to do too much work. One crucial "plastic characteristic" is definitely lost in the transformation, and that is the profile shared with the Copper.

The Copper materialized the very principle of substitution and sacrifice entailed in comprehending a cultural system; it rested at the cusp between a practice of sculpture and the abstracted function of sign or substitute. The value that inhered in a particular Copper was based on the history of its past transactions, which were never necessarily visible in its appearance. Where they were—when pieces had been cut away and distributed at potlatch gifts—this actually caused the Copper to lose its visual completeness and integrity, and it retained its place within the system of exchange even when reduced to the barest skeleton of its raised ridges. Indeed, it could be said to have realized its maximum potency when it ceased to have any visibility or presence whatsoever, that is, when it disappeared into fire or beneath the sea.

It thus represents an instance of the very condition of intelligibility present in the art—the necessary passage from sensory presence to

immaterial difference—actually assuming discrete physical form. This is, I think, unusual, and it was perilous to the potlatching artistic complex of which it formed such a crucial element. Lévi-Strauss's point of purchase on the system of masks prevailing among the Salish and Kwakiutl turns out to be more than the system's most revealing instance of discoordinate form; it turns out to be the key to the historical fate of this entire artistic complex. The direct correspondence between the *Swaihwé* and the Copper maps these object-types onto another axis of description, one of rapid and ultimately violent historical change, which crosses at a right angle over Lévi-Strauss's largely atemporal description in mythic and ritual terms. Europeans were both the source of the precious metal that went into the Coppers and the ultimate enemies of the nonutilitarian allocation of wealth that these devices so potently symbolized and allowed their bearers to enact. While he does acknowledge the proliferation and elaboration of ritual objects brought on by European tools, trade, and the consequent expansion of a local cash economy, he leaves out of account the steep descent of this climbing trajectory that took place in the first decades of the twentieth century. This abundance of art and its supporting apparatus of production then suffered an enforced dismantling at the hands of the Canadian federal authorities and remained in eclipse for decades afterward.

The Protestant impulses behind this act of iconoclasm tie the experience of Native American artists and patrons to that of certain of their counterparts in Reformation Europe. If the essence of historical explanation lies in accounting for change, episodes of iconoclasm offer the art historian cases of the most accelerated change in the viability of an achieved artistic complex, a speeding up of the processes of dissolution that ultimately overtake them all. The following chapter, following the work of Michael Baxandall, will address these two instances of iconoclasm together, identifying within these acts of destruction the very forces that had stimulated the making of the menaced objects in the first place. The historical phenomena of breaking down—which is the literal sense of the term "analysis"—then can itself serve as a tool of interpretation.

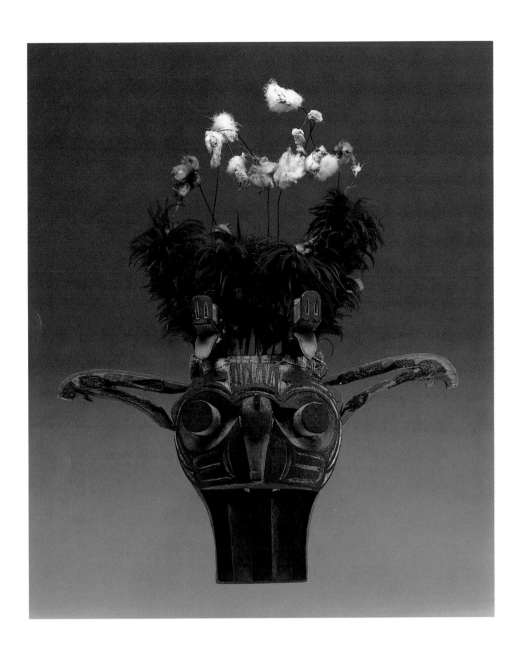

PLATE 1. Swaihwé *mask, Coast Salish, British Columbia, wood,*
pigment, and feathers, 81.6 × 49 cm., courtesy Department of Library Services,
American Museum of Natural History, no. 3850.

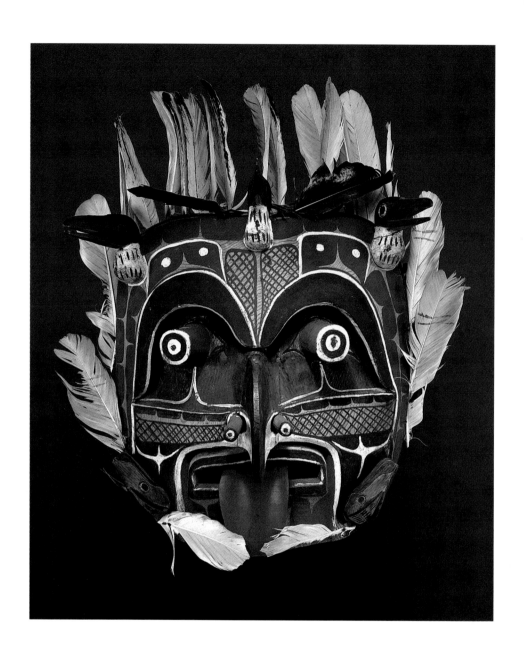

PLATE 2. Xwéxwé *mask, Kwakiutl, British Columbia, wood,*
pigment, and feathers, 25 × 63 cm., courtesy Department of Library Services,
American Museum of Natural History, no. 4545.

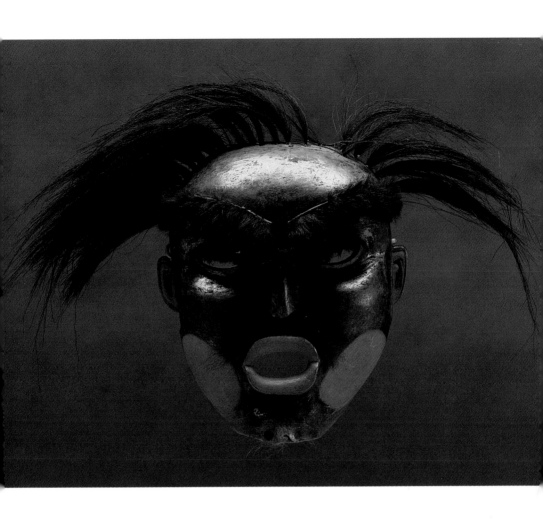

PLATE 3. Dzonokwa *mask, Kwakiutl, British Columbia, wood, pigment, and fur, 30 × 24 cm., courtesy Department of Library Services, American Museum of Natural History, no. 3834.*

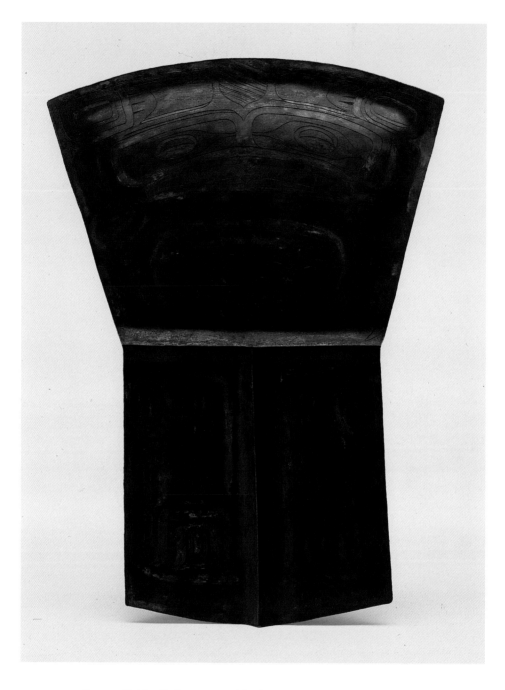

PLATE 4. *Copper, Haida, Alaska, copper with pigment, 75 × 53 cm., courtesy Department of Library Services, American Museum of Natural History, no. 3803.*

PLATE 5. *Veit Stoss,* Virgin and Child, *1510–20, boxwood, 20 cm. high, Victoria and Albert Museum, London.*

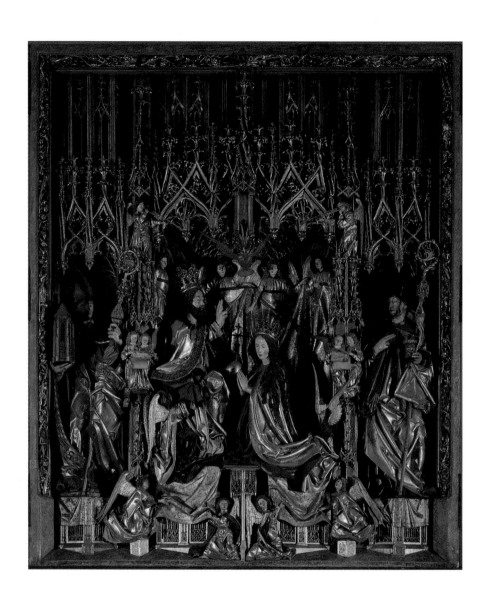

PLATE 6. *Michael Pacher,* Coronation of the Virgin, *1475–81, detail*
from altarpiece, limewood, gilding, and pigment, Pfarrkirche, St. Wolfgang,
Erich Lessing / Art Resource, New York.

PLATE 7. *Michael Pacher,* Coronation of the Virgin, *1475–81, altarpiece, limewood, gilding and pigment, 12.16 m. high, Pfarrkirche, St. Wolfgang, Erich Lessing / Art Resource, New York.*

PLATE 8. *Tilman Riemenschneider,* The Last Supper, *detail of* Altarpiece of the Holy Blood, *Rothenburg, St. Jakobskirche, Erich Lessing / Art Resource, New York.*

PLATE 9. *Carle Van Loo*, The Sacrifice of Iphigenia, *1757, oil on canvas, 426 × 613 cm., Potsdam, Sanssouci New Palace, Marmorsaal, Stiftung Preußische Schlösser und Gärten, Berlin-Brandenburg/Bildarchiv.*

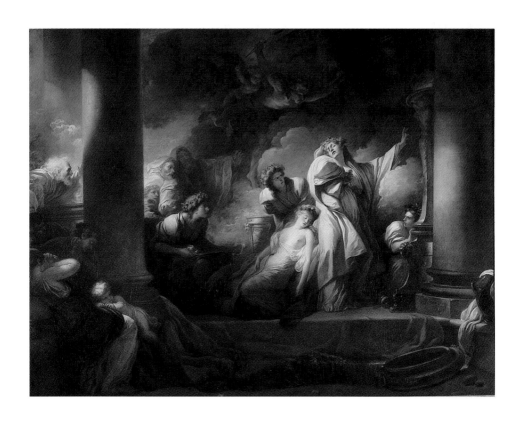

PLATE 10. *Jean-Honoré Fragonard,* Coresus and Callirhoë, *1765, oil on canvas, 309 × 400 cm., Musée du Louvre, Paris, © Photo* RMN *- Jean Schormans.*

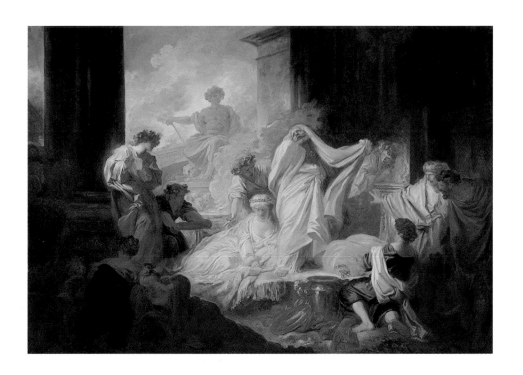

PLATE 11. *Jean-Honoré Fragonard, study for* Coresus and Callirhoë, *oil on canvas, 129 × 186 cm., Musées d'Angers, © Photo RMN - Gérard Blot.*

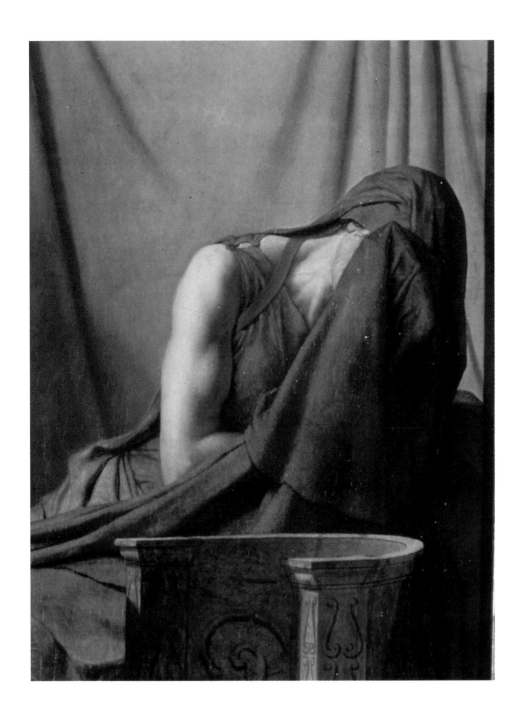

PLATE 12. *Jacques-Louis David,* The Lictors Returning to Brutus the Bodies of His Sons, *detail, Musée du Louvre, Paris,* © Photo RMN - G. Blot / C. Jean.

3 Starshake, or the Sense of an Ending

The two previous chapters have, in passing, conjured up a rare and remarkable confluence of high intellect with aesthetic passion in the New York of the late 1930s and early 1940s. The density and productivity of personal relationships within this loose community far exceeds the inevitably schematic picture drawn here—indeed a book several times the length of this one would be required to do it justice. Just to start, attention might have been drawn to Swiss-born Kurt Seligmann, the Surrealist painter and graphic artist who was among the first to leave Paris for New York, where he became a particularly close friend of Meyer Schapiro. The scholarly Seligmann had journeyed to North America only the year before, that time with the mission of acquiring significant Northwest Coast objects for the Musée de l'Homme in the French capital. After four months of living and gathering information among the Tsimshian, he secured from them a monumental totem pole from the mid-nineteenth century, but only after gathering all the living descendants of its original patron to approve the purchase. That permission entailed Seligmann himself being inducted into the clan and taking a Tsimshian name; indigenous carvers then undertook the necessary restoration before the pole was shipped to France. He then published the findings of his expedition in two places: the Surrealist-affiliated *Minotaure* and the scientific *Journal de la Société des Américanistes*.[1] When Lévi-Strauss produced his 1943 article on the North Pacific Hall of the American Museum of Natural History in New York, it appeared in the *Gazette des Beaux-Arts*, directed in exile by Georges Wildenstein, who happened to be the uncle of Seligmann's wife, Arlette.

Between the two French-speaking exiles, Seligmann the artist had the advantage over Lévi-Strauss the anthropologist in firsthand understanding of the conditions in the Northwest Coast. The former ob-

served little but decay in the transmission of myths and rituals to the younger generations, while the latter's *Way of the Masks* was to translate the objects in the North Pacific Hall into a vital ethnographic present.[2]

This is not to say, following a familiar line of criticism, that Lévi-Strauss was indifferent to history—he rightly disputes the charge that his structuralist approach blocks any consideration of change in cultures over time. Certainly, the historical passage of the *Swaihwé* mask from Salish to Kwakiutl (figs. 9, 12) is confirmed by the structural transformations in meaning that attended the transfer of the form from one culture to another.[3] This transmission took place recently enough to remain part of the verbal lore of the Kwakiutl,[4] and that fact signals the extent to which the distinctive flowering of Northwest Coast sculpture followed contact with Europeans and Americans. Much of its startling inventiveness presupposes the added facility afforded by imported metal tools. The power of the Coppers (plate 4)—those supreme objects of potlatch value—also followed from European contact, as all observed and surviving examples were fashioned from metal provided by Russian, English, and American traders.[5]

Schapiro, too, had seized upon a sudden stimulus to artistic productivity in choosing the portal sculpture at Souillac, which stands as something of a culmination to the rapid and widespread emergence of monumental stone sculpture in Europe from the later eleventh century. Its reappearance, on a scale not seen since antiquity, had likewise accompanied a rapid, qualitative transformation in the level of economic activity across the continent, manifested in trade, agriculture, munificent church building, monastic expansionism, mass movements of pilgrims, and exploitation of new territories within Christian Europe and reconquered Spain. The inevitable resulting tension between secular and dogmatic impulses propelled investment—material, intellectual, and psychological—in artistic expression as one conspicuous means of handling these tensions and imagining their resolution.

Something similar occurred along the Northwest Coast from the eighteenth century onward. Trade with Europe and America injected

even more wealth into one of the richest hunting and gathering societies in human history. For the elites, that meant more time and resources to manifest their prerogatives. The requirements of trade and the disruptions of colonization in turn suppressed traditional patterns of warfare and brought formerly isolated groups into closer contact, requiring yet more investments in order to establish new hierarchies and reinforce group identities.[6] All of this suggests a preliminary hypothesis that such conditions are propitious both for an exceptional intensity in artistic innovation and for the art historian's analytical purchase on that phenomenon. But Lévi-Strauss does not confront, any more than did Schapiro, the possibility that the very tensions engendering such abundant and distinctive art could exceed its powers of resolution and harmonization. And for the societies of the Northwest, such a moment arrived in catastrophic form.

Seligmann, in his account of the Tsimshian, had relayed a familiar story of decline and demoralization in traditional rituals and beliefs under the pressure of Western secular rationality—as Lévi-Strauss himself was so famously to do in his South American memoir, *Tristes Tropiques*; but Seligmann did not emphasize the extent to which the Native Americans of the Northwest Coast had exploited the resources of the West to intensify some of their key traditional practices, nor did he highlight that the governing Canadian authorities had been forced to resort to exceptional measures in order to reverse this process.

The flash point was the ritual of the potlatch, the central ceremony of status and identity across the region. It is a mark of the ideological success of the official point of view that the term has entered the general language as a synonym for unstinting, even ruinous, generosity on the part of the host. The assumption has been that tribal chiefs locked themselves into a mad, open-ended competition for status, wasting mountains of usable wealth in the process. There was, in fact, relatively little such competition implicit in the potlatching system: rather, an individual was born or married into possession of all the names, titles, and symbolic property that he would ever own. The potlatches marked these predetermined steps in the life of a high-status individual, the acquisition of rights that were acknowledged, above all,

in the way one was treated in the potlatches of others. Pyramiding obligations were calibrated into a transparent system of mutual obligation and loans of potlatch goods at interest—and these rarely exceeded what families realistically could bear.[7] What the wealthy Kwakiutl and others saw as the cheapness of European goods created the usual effects of inflation as more and more of these tokens of wealth—trade blankets or sacks of flour—were injected into the system (fig. 16).

The Coppers, however, did create the most visible and inflammatory impression of hyper-inflation, which doubtless fostered the myth of self-destructive waste. Coppers were frequently sold as a prelude to a potlatch, and etiquette dictated that the offer to a potential buyer could not be refused (fig. 17). This was frequently a last-minute device to gather sufficient goods to conduct the ceremony, so the values escalated with the general expansion of the potlatch economy (famous Coppers acquired names that were very like those attached to esteemed individuals: "Empties the House of Wealth" or "All Other Coppers Are Ashamed to Look at It").[8] The drowning of a famous Copper thus had the apparent effect of wiping away a vast amount of accumulated credit. Coppers were thus the most visible crystallization of the apparent excess that caused the Canadian government in 1885 to enact a law suppressing the potlatch.

While the ceremony was already on the wane among most Northwest Coast groups, the Kwakiutl managed obdurately to persist in what they disarmingly called "our manner of trade and recreation" with little interference, indeed with a good deal of tacit support from resident Anglo-Canadians, who saw no reason to harass and antagonize their neighbors unnecessarily. Between 1919 and 1922, however, renewed determination at the federal level manifested itself in a series of successful prosecutions for illegal potlatching, after which traditionalists were forced into various clandestine—and for a time successful—stratagems in order to carry on.[9] Symbolic investment in masks and regalia nevertheless declined rapidly (fig. 18), as the accumulated effects of disease and resulting population loss, alcoholism, out-migration, Christian evangelism, the decline of the native fishing fleet, and the economic effects of the Depression conspired to make

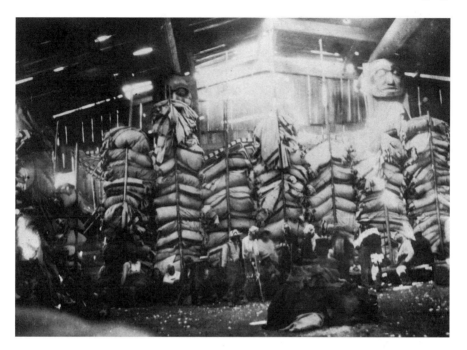

FIGURE 16. *Potlatch blankets piled in a Kwakiutl house, courtesy Department of Library Services, American Museum of Natural History, no. 22861.*

the potlatch network a shadow of its former self (that is, until its more recent revival by indigenous activists). The key indicator of its fate was already evident by the 1920s, when transfers of Coppers virtually ceased (fig. 19).[10]

To discover the primacy of the Copper in Northwest Coast myth and in its vulnerable works of art is to uncover the modern and cosmopolitan amid the apparently timeless and traditional. The Canadian authorities may have regarded potlatches as irredeemably alien to Protestant priorities of thrift and utility; but the phenomenon of inflation and the denomination of value in identical, interchangeable units of trade bespeaks a thorough immersion in the more abstract reaches of the capitalist marketplace. That brought into art the self-liquidating dynamic of capitalist activity in general: global trade was not responsible for the conceptual intricacy of the art, which had clear and deep indigenous origins, but its stunning quantity and variety in the postcontact period were part and parcel of that European-based

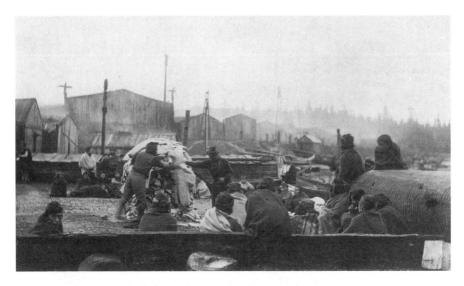

FIGURE 17. *A Copper purchase ceremony, Fort Rupert, 1894,*
photograph by O. C. Hastings, courtesy Department of Library Services,
American Museum of Natural History, no. 336066.

system. The compelling quality of the art cannot be separated from its
built-in contradiction to a moralizing iconoclasm that came to have
the vengeful upper hand. A further cause of Anglo-Canadian outrage
was the fact that ascending potlatch stages entailed serial marriages to
one or more women, whose family or families possessed the rights to
crucial symbolic crests. This made the gift exchanges appear to the
Christian authorities as a species of prostitution; men were further
accused of selling wives and daughters into prostitution in Canadian
towns in order to gain funds for lavish potlatch expenditure.[11] The
ceremony and its visual embellishments seemed to them the palpable,
pagan embodiment of Avarice and Unchastity, whose figures haunt
the lower portals of Romanesque churches (fig. 20). Native North
Americans were made to pay the price for moral contradictions that
were inherent and perpetually unresolved in the culture of Europe.

.

The two previous chapters have drawn attention to the power of
(apparently) marginal examples as key instruments of art-historical

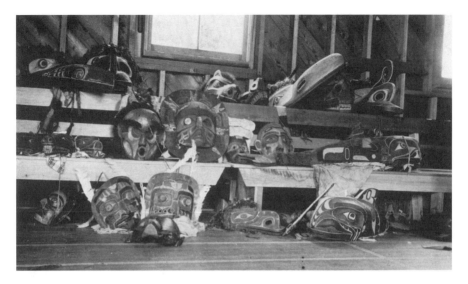

FIGURE 18. *Surrendered Kwakiutl masks, including Dzonokwa and Xwéxwé types, 1922, photograph by Rev. V. S. Lord, Royal British Columbia Museum,* PN 11637.

understanding. The ultimate margin for any artistic complex is its historical eclipse. Can this phenomenon, the coming to an end of a distinct phase of art, be made into a tool of analysis? This is another way of asking whether the ending is already present in the very development and nature of the art in question.

Despite the dramatic eclipse of the potlatch, Lévi-Strauss provides a sense only of the upward historical trajectory that made an already rich visual repertoire even more visually and materially elaborate. Though it is crucial to recognize that the potlatch persisted with considerable force in underground forms and in areas inaccessible to Europeans, the prohibition inevitably did immense damage to the networks of skill and inherited knowledge on which any developed artistic complex depends. Moreover, government agents were keen to confiscate masks, regalia, and Coppers, thus diminishing the inherited stock of revered models and the incentive to make more (figs. 23, 24). As a sharply rising curve of development in itself provides the conceptual armature for his (and Schapiro's) mode of interpretation, so a subsequent downward slope might logically do the same. And con-

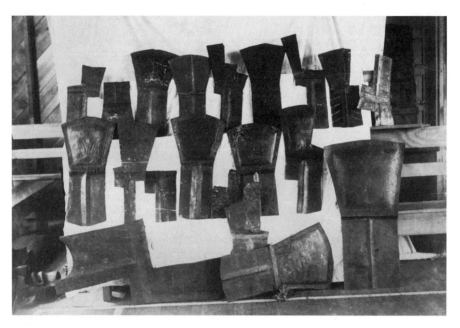

FIGURE 19. *Surrendered Coppers, 1922, photograph by W. H. Halliday,*
Royal British Columbia Museum, PN *12194.*

firmation for that hypothesis can be found in a scholar from a generation younger than these two. Michael Baxandall's *The Limewood Sculptors of Renaissance Germany,*[12] published in 1980, builds its analysis around the sense of an ending in history: first, the object's own real or potential life history, pregnant with the possibility of a catastrophic conclusion, and second, the sensual vividness of art reaching the limits of tolerance in the very society that required it, thereby suffering a violence that amounts in retrospect to analytical dissection.

To trace this train of methodological logic to Baxandall (and there are few, if any, other paths it could have taken) is also to open up the preceding discussion beyond the particular circumstances of New York in the late 1930s and 1940s, that is, beyond the great drama of the Depression, anti-Fascism, exile, war, and the Holocaust, which put these Jewish intellectuals into a realm of mental life that few of us can now imagine. For all that their intellectual innovation was bound up with the courage and resourcefulness with which they met those conditions, that level and quality of innovation must be decoupled from

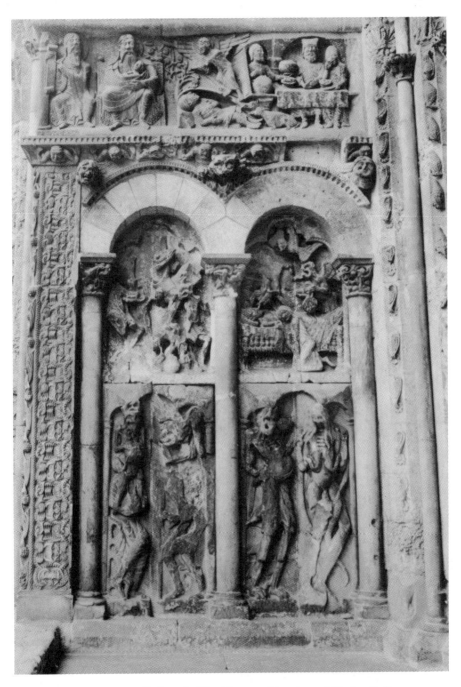

FIGURE 20. *West inner wall of porch, "Punishment of Avarice and Unchastity,"*
Church of St. Pierre, Moissac, photograph by David Finn, in Meyer Schapiro,
The Sculpture of Moissac.

the accompanying drama in order to extract its generalizable import. And in Baxandall's case, a comparable leap in thought came out of the quiet galleries and storerooms of the Victoria and Albert Museum in the peacetime London of the 1960s and 1970s.

Though famously a specialist in Italian Renaissance art and rhetoric, Baxandall spent his earlier career overseeing the V & A collection of south German sculpture. The examples in his charge represented an exceptional upwelling in quantity and richness of sculptural production (plate 5) in a comparatively short period, this one having occurred between the 1470s and the 1520s across a swathe of Europe from the upper Rhine in the west to Bavaria and even Poland to the east. Most German sculptors had previously been attached to the workshops or lodges of great churches and cathedrals, much as we assume the anonymous creators of Souillac's portal imagery to have been; but, from around 1470, the center of gravity had decisively shifted away from ecclesiastical employment to urban workshops producing portable sculpture.[13] In keeping with that change, the preferred medium shifted from stone to light and flexible wood, frequently embellished with richly painted, polychrome surfaces (plate 6). Greater independence and portability of the art paralleled freer movement on the part of hundreds of sculptors between centers, particularly a drift eastward from Netherlandish and Burgundian centers ranging across the southern tier of the German-speaking world. The concentration of new sculpture in city workshops also distanced the art from princely patronage. Sculptors—whether established or nomadic—were drawn into a newly dynamic social ferment, characterized by swelling urban populations, an economic boom combined with rising price inflation, and growing inequality in the distribution of wealth.

Baxandall thus seized on art produced in circumstances strongly reminiscent of those presented in the two studies examined in Chapters 1 and 2. What was more, he produced a book widely acknowledged as one of the defining works of contemporary art history. But what precisely it defines, after all the homages have been considered, still remains unclear. It is his habit to forswear any ambition or even interest in the sort of explicit, programmatic demonstration of a sys-

tem such as those offered by Schapiro and Lévi-Strauss. To this end he brandishes the robust empiricism and suspicion of abstraction habitual to the English museum curator he once was. *The Limewood Sculptors* appears almost fragmentary, a composition of illuminating but discoordinate parts. That quality, along with the modesty and poise of its style, may have allowed it to escape the contention that still surrounded the idea of a social history of art at the time of its publication in 1980; and it has retained a capacity to be almost all things to all people.

This was a worthy service to the art, to expose it from every side in a way that elicits the broadest sympathy and engagement; but somehow the intriguing strangeness of the book, its unexpected ordering of topics and sudden shifts in direction have fallen out of discussion. The strangeness is surely one of design, though describing that design can seem almost a work of interpretation in itself. Its parts appear so encyclopedic—on guilds and workshops, analogies with other cultural forms like master-song and calligraphy, and the effects of light and point of view on the pious viewer's apprehension of an altarpiece, to name just a few—that the first challenge to the reader is to find within it a key somewhere to the logic of the whole.

.

To recommend that *The Limewood Sculptors* be read against the grain is perhaps to indulge in too easy a play on words, but it is consistently helpful to be watchful for contraries: to discover its grandest abstractions, look in passages of exposition that seem the most matter of fact. Early in the book, he provides what seems to be a freestanding chapter, entitled "Materials," on the physical properties of wood from the lime, or linden, tree, the dominant material in the complex he sought to describe.[14] It presents itself as straightforward description of one natural circumstance for the art. This brief text lays great emphasis on the peculiar cellular structure of the wood, the desirable benefits it offers the sculptor, and also the serious constraints that it imposes on his formal decisions. The most attractive aspect of limewood is the unusual evenness with which its fibers and cells are distributed.

This makes it exceptionally tractable for carving in detail, as it lacks a distinctive, resistant character of its own at this fine level.

For larger forms, on the other hand, it has a compensatingly strong intrinsic character, one apparent not so much at the time of carving but in its life over time. The shrinkage and swelling of limewood in response to atmospheric conditions is far greater in the circumferential axis than in the radial one; it is also much greater in the porous outer wood than in the dense inner core. Unless the core wood was removed (figure 21), the sculpture would be afflicted by vertical cracks radiating from the center, a phenomenon known as "starshake." Even after hollowing out the core, it was crucial that any broad forms be carved in such a way that they were tied to the center of the block at only one point. Otherwise two or more points of anchorage would expand and contract differently and thus tear the outer form apart. Here again, the virtues of limewood are its potential undoing: The even distribution of its internal elements means that it is open to the incursion of humidity everywhere on its surface, so that there is no continuous process of seasoning, but rather a continuous, slow-motion pulsation of the sculpture. The very lightness of the limewood, which makes it so attractive to the carver, simultaneously lends it this susceptibility to this catastrophic splitting, as opposed to the gradual warping of denser woods like oak.

At the time of the book's publication, conservatives in art history welcomed this discussion in particular as a wonderful "return to the object" in the midst of what they regarded as a proliferation of heretical approaches to the field. They might be forgiven this self-satisfied perception in that Baxandall frames his discussion with extreme discretion: he insists on the specifically historical nature of the sculptor's insight into wood to the point that he coins a term for it from an archaic vocabulary of the period: "chiromancy," a word he borrows from the alchemist Paracelsus. But that exaggerated vigilance against anachronism suggested something more was going on, something still not being said, something perhaps beyond explicit articulation. It is only in grasping the parallel trajectory of his next chapter—which bears the disarming title of "Functions"—that the reader can see the

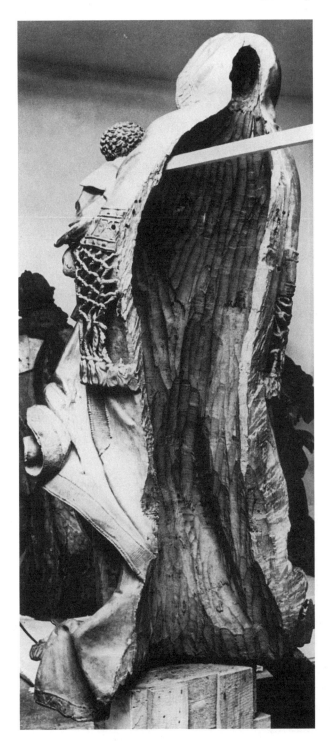

FIGURE 21.
Hans Leinberger,
Virgin and Child
(seen from behind),
1513–14, High Altar,
Moosberg, Stiftskirche,
Bayer, Landesamt
für Denkmalpflege.

way this exposition of functional botany works as a metaphor for his logic of interpretation. The unpromising circumstances of limewood sculpture were not obstacles to be overcome but the necessary conditions for the art to exist in the first place, though they ensured that it might not survive its context. Those forces were inextricably bound up with creativity itself; in the production of art, exceptional quality can be the condition of its own undoing; so too destruction of a form provides the zero term required for its successful interpretation.

.

Toward the end of the chapter on materials, in a discussion of limewood's receptivity to various surface treatments, Baxandall briefly evokes the near-hallucinatory effects of the paint and gilt applied to these ensembles of figures. "Seen at their best," he says, "which is on a day of mixed cloud and sun, . . . one's usual perceptual skills are invalidated for a time, they effectively deny the mundane and become religious images of a singular kind."[15] This observation sets the stage for the "Functions" chapter, the first section of which begins quietly with established church doctrine on the devotional use of images, that is, German writers of the fifteenth century rehearsing the old arguments in the face of the Second Commandment's bald prohibition of visual likeness. Repetition of these arguments, he soon makes plain, arose from the powers of the new splendor of polychrome, hallucinatory imagery.

In the second section, subtitled "The Winged Retable," he broadly establishes the scale of the phenomenon: From about 1470 onward, there was an explosion in the production of elaborately carved altarpieces (plates 6, 7). Some were for high altars and therefore the expression of a community's devotion and self-regard; but many more were commissioned by wealthy individuals and newly assertive confraternities, all "correlative," as Baxandall puts it, "of the same fragmentation of social sense" engendered in the economic boom with all of its attendant dislocation of settled statuses and habits.[16] The format of the winged retable suited these conditions; the shrinework frame "insulated the sculptor from any need to conform in manner with

other art in a church, it provided elaborate ornamental structures with or against which the sculpture could and did play subtle echoing and contrapuntal games."

He goes on to say, "[T]his disposition to the intricately counterbalanced figure became so much a part of Florid sculpture that the carvers often persist with a self-sufficient version of it in figures designed to stand on their own. . . . [T]he counterbalancing manifests the cult of many saints. Such figures are, to stretch a point, a little polytheistic; it is a nearly hagiolatrous *contrapposto*."[17] The term "Florid," his favored designation for this entire phase of sculpture, rings with an old-fashioned sound. The same is true of his other explanatory terms and devices, from the seeming material determinism of the aforementioned chapter on "chiromancy" to the distinction he draws between native and Italianate traits (the *Deutsch* and the *Welsch*), which calls to mind old strains of cultural chauvinism in German scholarship. But in each of these instances, he takes what had been a primitive theory of positive determinism and changes its valence to a negative one, whereby style, material, or national culture appear only as provisional entities, threatened as much as sustained by the conflicting elements that give them substance.[18]

So it is central to his interpretation that the same impulses prompted both the iconophilic piety of later fifteenth-century Catholicism and the iconoclastic reversals of the Reformation. Decades before Luther, newly confident citizens, wanting more personal and responsive forms of worship, began to take the conduct of religion more into their own hands: They formed or joined confraternities that allowed a lay presence and direction in worship; they asserted the independent interests of their parish against the diocese and even their own priests; they endowed preacherships so that there would be clerics interested in speaking directly to their fears about salvation; and they consumed an outpouring of new devotional tracts, illustrated catechisms, and confessional manuals in the vernacular. The expansion of cities, increased personal mobility, and an economic boom helped engender intense anxiety about the afterlife and fear of hellfire. The dilemma for the sculptors was that the more they answered the demand for inten-

sity of experience and conspicuous economic sacrifice by donors, the more they called attention to the worldly attractions that helped engender anxiety, fear, and guilt in the first place.[19]

It would be useful, given time, to trace Baxandall's analysis of the way that the forces of the capitalist marketplace, inside and outside art, converged to engender a dangerous suggestion of idolatry and thus force Florid sculpture into harm's way. While the endowed preachers helped fuel the eventual Reformation on behalf of their congregations, the retable altarpiece rendered all too vividly the compromises of pre-Reformation piety and thus lost all persuasion for a large part of the population suddenly vigilant against visible luxury. Other practices could adapt themselves to the purposes of reform, but Florid sculpture, because it was cumbersome, unchanging, and physically vulnerable, remained hostage to its bypassed historical moment. The conventions of the time did not allow sculptors the means employed by the medieval artists of Souillac to channel—through the devouring beasts of the trumeau—anxiety, fear, and guilt into a redemptive experience of the art, which likewise plays the most "subtle, echoing and contrapuntal games." (In other respects as well, there are strong parallels between pre-Reformation miracle-working sites for pilgrimage and the Souillac monks assiduously promoting their penitential cult of the Virgin among the laity, in which the attractions of a startlingly elaborate work of art stood in for the major relic they never managed to obtain).[20]

Of primary concern here is the predictive power of his scheme of analysis, his identification of the impending death of a form in its living tissues (the very choice of the word "florid," from "blooming," carries traditional connotations of temporary beauty). At the end of the crucial chapter on functions, he writes, "It is an inherent part of its vulnerable charm that there were people who wanted to destroy it even while it was being made."[21] That typically understated, almost courtly expression "vulnerable charm" contains an entire thesis. "Charm" translates into a claim for exceptional quality, meaning worked objects with the greatest ability to reward prolonged examination and thought. Persuasively to synthesize elements threatening al-

ways to fly apart is one objective criterion for quality, that is, one that does not depend on assertions of taste or prejudice.

His claim, therefore, is shadowed by the real negation in history that is iconoclasm. So of necessity he must suspend his attention to this realm of functions and move abruptly and startlingly to the end of his story, to the iconoclasm that took hold in the Protestant cities from around 1520 as reformers sought to stamp out all idolatrous abuses at their source (as, centuries later, the Kwakiutl found themselves at odds with a censorious Canadian Calvinism that had its roots in this same historical moment in Europe). Wholesale destruction of church images, he points out, were infrequent, confined to a southern tier under the sway of Zwingli. Luther took a moderately tolerant line out of a general fear of popular zealotry, while city authorities often withdrew sculpture or allowed private donors to retrieve their own altarpieces. Yet the outcome was still, he observes, "a general disaster to the craft of sculpture," a catastrophe of immeasurable proportions.[22]

Baxandall's analysis of the circumstances of limewood entailed imagining the work of sculpture tearing itself apart from within: if the sculptor failed to anticipate its conflicted internal forces and strains, if he failed to find ways to channel their contradictions to productive or at least harmless directions, they would ultimately leave the piece in fragments. To understand the sculptor's thinking requires imagining with him this hypothetical disaster. The iconoclasm of the 1520s performed a parallel act of destruction upon the entire professional and aesthetic complex of Florid sculpture. Sculptors in Strasbourg— where iconoclasts were thorough—found themselves with no choice but to plead with the city council for relief in order to feed themselves and their families. Even in cities that remained Catholic, apprehension over awakening further dissent over the church's worldly abuses caused patrons to forgo conspicuous expenditure; the direction of Lutheran piety was decisively away from the altar and toward the pulpit and the sermon. The prosperous, busy, densely interconnected world of the city sculptor—linked as he was with joiners, gilders, and painters in the production of these intricate altarpieces—was shattered at a stroke.

FIGURE 22. *Anonymous,* Portrait of a Merchant, *ca. 1530, South German,*
Staatliche Museen zu Berlin-Preußischer Kulturbesitz Skulpturensammlung.

If there remained a substantial amount of work for sculptors to do,
it was in more fragmented and narrowly defined genres.[23] One was the
relief portrait (fig. 22), a mode of art hardly known in Germany before
1520 but commissioned in some numbers afterward. There was also
demand for small religious images that reproduced for private devo-
tion certain motifs that had been resplendently arrayed in the retable
altar (fig. 23). Post-Reformation communities no longer manifested

FIGURE 23. *Hans Daucher,* Virgin and Child with Angels, *1520, Solnhofen, limestone with marble inlay, 42 × 31 cm., Stadt Augsburg.*

solidarity and pride in high altars but did offer commissions for foun-
tains in civic squares (fig. 24). Then there were statuettes and reliefs in
pearwood (fig. 25) that allowed concentrated attention to the seduc-
tive female form—once only implied under the robe of the female
saint—in the full nudity permitted by a scene of Adam and Eve or the
Judgment of Paris (these Baxandall terms "fleshly cabinet pieces"). "It
seems almost," he states, "as if the Reformation decade may have con-
cretely analysed out a mixture of functions within pre-Reformation
sculpture: the major devotional function having been extracted,
minor residual functions are being precipitated as separate minor
genres."[24]

Baxandall's conceptual move here parallels that of Lévi-Strauss in
his reading of the transformation undergone by the Salish *Swaihwé*
mask as it passed into the hands of the Kwakiutl. The embedded sign
of good lineages and good fortune, that is, the shape of the Copper,
was likewise "analysed out," leaving a collection of residual signs that
attached themselves to a new vehicle and reversed their previous func-
tion. Individual pride, political solidarity, and sensual fantasy had
likewise been bound up in the German retable altarpiece, but each
quality had been sublimated into a system that turned them against
their worldly origins. The subtraction of their integrating matrix
flipped each element back into its nonsublimated point of origin.
Their totality—and therefore the sum of the possibilities for sculp-
ture—was now a weak supplement and qualification to the power of
the Protestant word.

The task of the interpreter is then to reverse this analysis effected by
history and turn it to the understanding of the previous synthesis, one
understood now as a fragile, unstable balancing act. To this end, he
conducts a kind of thought-experiment, imagining a mode of lime-
wood sculpture that succeeds in channeling the incipient iconoclasm
that preceded the Reformation into more self-evident visual forms:
"[O]ne might expect to find," he proposes, "carvings in which some of
the grievances were being met; an image had to be an image, but it
could go some way towards disarming criticism by avoiding as many
as possible of the characteristics that made it offensive to the fastidi-

FIGURE 24. *Peter Flötner,* Apollo *Fountain, 1532, brass, 100 cm. high, Nuremberg, Stadtmuseum Fembohaus.*

FIGURE 25. *Anonymous,* The Judgment of Paris, *ca. 1530, Bavarian pearwood, Victoria and Albert Museum, London.*

ous Christian."[25] He then proceeds with a hypothetical exercise in prediction by a reversal of traits, just as Lévi-Strauss had predicted the configuration of the Kwakiutl *Dzonokwa* by changing the valence of each element in the Salish *Swaihwé*:

It would not be very magnificent in its material, nor *hurisch* or *kupplig* [pandering] in its characterization, nor distractingly elaborate in its ornament and detail. . . . It might well be impersonally or collectively endowed thus not redolent of individual display or *Hoffart* [pride], typically on a high altar rather than a side-altar, if on an altar at all. It would avoid hagiolatry by representing not magical marginal saints out of the Golden Legend but the central corporeal matter of Christianity—above all, Christ, his Life and Passion. To discourage devotional abuse it might be more narrative than devotional in its manner, telling a story to those who cannot read rather than offering itself for veneration. For the same reason it might also ward off any disposition in the beholder to confuse it with the divine original: one means to this kind of disassociation was monochromy.[26]

Having laid out this set of negative stipulations, he concludes, "The sculptor who came closest to conciliating first-class Florid sculpture with such a pattern of piety was [Tilman] Riemenschneider of Würzburg."

The Altar of the Holy Blood (fig. 27), commissioned from Riemenschneider in 1501 by the city council of Rothenburg, brings Baxandall's thought-experiment to life. For the burghers of Rothenburg, one prime attraction of Riemenschneider was the exceptional cheapness of his work, but that economy was achieved at one and the same time in the qualities that best accommodated their unstable situation and watchful disposition. The simplified, repetitive and exaggerated physiognomies made them easy to carve by Riemenschneider's assistants (fig. 26); replacement of polychrome painting with a uniform stain (plate 8) eliminated the expense of a subcontractor; but these qualities also lent the work "a certain puritanism," as Baxandall puts it, "in

which parsimony has moral weight and a cool narrative is settling."[27] The sculpture enshrined the relic of its name and was the destination of many pilgrims, with all the potential that spelled for unsavory miracle-working and indulgence-mongering. The burghers of Rothenburg endured the rule of a magnificent and costly church establishment headed by the Prince-Bishop, while they had as much to fear from restive poorer classes of artisans and peasants outraged by the excesses of a priestly aristocracy. Riemenschneider synthesized these volatile circumstances into art—at least for a time. But just how volatile they were he was to come to know in 1525, when he was imprisoned during a peasants' revolt and, as one story has it, suffered his hands being broken.

.　.　.　.　.

Near the beginning of *The Limewood Sculptors*, Baxandall declares that "only very good works of art, the performances of exceptionally organized men, are complex and co-ordinated enough to register in their forms the kinds of cultural circumstances sought here; second-rate art will be little use to us."[28] The unstated but fundamental aim of his book is to address how great episodes in artistic creation come about, why they are so rare, why they never last long—and why they are so difficult to talk about in these terms. These are questions that he would probably never dream of putting in so bald a form; once stated, they are probably susceptible only to banal answers. But the lesson of Baxandall's book is that questions of such generality are in no way beyond productive engagement. The argument will proceed from the structure of exposition, the arrangement of elements that are in themselves matters of empirical description. It will be the accumulated density of such description and the increasingly evident coordination of elements in an object—with the realization that such coordination is startlingly rare in our everyday commerce with things—that will lift the reader into another realm of intellectual engagement with it. Un-

FIGURE 26. *Tilman Riemenschneider, detail of* Last Supper, *Christ with Judas and apostles,* Altarpiece of the Holy Blood, Rothenburg, St. Jakobskirche, Bildarchiv Foto Marburg.

FIGURE 27. *Tilman Riemenschneider,* Altarpiece of the Holy Blood, *limewood, 9 m. high, Rothenburg, St. Jakobskirche, Bildarchiv Foto Marburg.*

less the reader actively reassembles the broken parts, the account as a whole, however compelling in its parts, will remain inert.

It is a risky way of proceeding, but successful demonstrations of aesthetic distinction are increasingly difficult to achieve in a skeptical age like our own, one inclined to surrender the whole concept to a resigned assumption that art—or what was once called art—is just one piece of an undifferentiated visual culture. But that skepticism can provide the pressure necessary for the idea of distinction to regain its purchase and with it the ability to recognize and preserve a discipline of thought and feeling embedded in the making of art. That ability entails interpretation, and interpretation remains an act of violent substitution; competing interpretations can descend into a warlike stalemate with the object of the argument becoming entirely lost from view. One lesson of Baxandall's *Limewood Sculptors* is that in special circumstances history itself has enacted the violence necessary to understanding, so the willful interpreter can withdraw from center stage, let his or her material do the work, and thus restore some validity to the ideal of objectivity.

But what do we do under the more usual circumstances when neither the physical matter of an art form nor its historical moment threatens to break it into analyzable pieces? The last of these chapters will try out one modest response to this question.

4 Sacrifice and Transformation

The exemplary cases offered in the three previous chapters—Meyer Schapiro's Romanesque carving, Claude Lévi-Strauss's masks of the Northwest Coast, Michael Baxandall's sculptors in limewood—display some strong built-in similarities. Each represents an episode of extraordinary acceleration in the scale and intensity of artistic activity, concentrated investment, and new complications of form; art, in all three, found itself pressed to do more than the culture had expected or experienced in the past. This deepening and expansion of effort was propelled in each case by rapid increases in wealth, restless population movements, and urban settlement on a new scale; prosperity grew, but so did inequality in income; basic productivity was complicated—certainly for the Kwakiutl and pre-Reformation Germans—by increasingly abstract and speculative regimes of banking and finance. These unsettling developments engendered increased anxieties about social position and status; and such worries both fostered and clashed with heightened fears about correct religious observance. The upshot was more conspicuous forms of symbolic display and heightened concern over their visual impact, which made patrons more demanding and artists more imaginative and resourceful.

At the same time, it is important to recognize that each of these episodes remained within the network of a cult in which three-dimensional objects played an essential part as apparitions of a higher reality (that belief caused the work to flourish but could put the physical survival of these objects at risk and imperil the entire cultural edifice that sustained their exceptional character). That common characteristic raises the question as to how one might move beyond these examples into a wider sphere, and, specifically, how to move from cult

sculpture to the secularized practices of painting that make up so much of the more recent historical record in Western art.

What follows cannot pretend to the scope and import of the art-historical work considered this far. It will be all the more exploratory and provisional in that it must come from those areas of art history in which the author can personally claim some research expertise. But if it is possible to go forward in light of these limitations, this suggests that many other paths may lead off from the body of thought adumbrated in Schapiro, Lévi-Strauss, and Baxandall.

.　.　.　.　.

In this endeavor, a first course of action would be to try at least to match the basic conditions in economic and social life that the three case studies share. It is not difficult to discover many of the same features in the mid-eighteenth century era of the high rococo in France. There was a newly powerful class of patron grown rich from the ballooning of the financial markets and by serving as middlemen in the state-sponsored expansion of the national economy. Privatization of functions once performed directly by the state accelerated this shift of resources. Simultaneously, the share of this expansion retained by the state was squandered in profitless wars and colonial adventures, leaving an even greater portion in private hands, which allowed the more ostentatious new patrons to surpass the traditional elites in outward splendor; for that reason the former took an ever keener interest in sponsoring and acquiring paintings.

But what of the concerns of piety that had so exercised the new rich of Quercy, Nuremberg, or Vancouver Island? This was a time, by contrast, when the new rich were among the most receptive to the ideas of the Enlightenment, and piety was slipping away from the rituals of Christianity and assuming the secular, even pagan clothing of Virtue, which is to say, a moralizing concern for the well-being of one's fellow citizens. By the 1760s, Virtue had become a near-cult and Jean-Jacques Rousseau its high priest. For its places of pilgrimage, it seized on public venues of art: first the theater, a natural home for the guild of letters, but also—and increasingly—the public exhibitions of painting

held every two years in the Louvre, the so-called Salons, where the best contemporary art would vie for attention and approval from the large and broad audiences admitted free to the event.[1]

But such a transition from a supernatural cult to a secular one cannot be painless, nor can it entirely free itself from the residues of religious observance, from hopes and fears over salvation in a disenchanted world. In line with the lessons offered in the three previous chapters, the first step is to look for particular events in the eighteenth-century art world where that contradiction seemed to be biting hardest. One theme in particular took on a new urgency as religious certainty declined: the classic stories of mortal sacrifice—from the biblical Abraham's sacrifice of Isaac to its pagan counterpart in Agamemnon's sacrifice of his daughter Iphigenia—test faith and obedience to divine dictates against the commands of feeling; and for the eighteenth century, feeling had nearly the same degree of sacredness.

.

It was the theme of Iphigenia that prompted the most ambitious academic painting seen in the Salon for decades, Carle Van Loo's monumental entry of 1757 (plate 9). At first encounter, this was the furthest thing from a marginal or incomplete work of art, that is, on the anomalous models of Souillac or the Salish *Swaihwé*, and it offers nothing answering the description of "discoordinate composition." At some fourteen by twenty feet, the sheer size of the canvas—with all of its attendant preparations—placed the painting at the center of France's official artistic culture. The commission came from Frederick the Great of Prussia, who was a great admirer of French culture and was expanding his palace complex of Sanssouci outside Berlin as a northern Versailles. The onset of the Seven Years' War in 1756 had drained the treasury, and no funds existed in France for painting on this scale. Despite this potentially embarrassing financing from one of France's enemies in the conflict, the painting was nonetheless seized upon as a manifesto of Gallic mastery of elevated pictorial drama.[2]

Van Loo's climactic scene roughly follows the version of the myth given in Euripides' tragic drama *Iphigenia in Aulis*. In brief, Artemis

has stilled the winds so the Greek fleet cannot sail to its conquest of Troy; the priest Calchas divines that Artemis can only be appeased by putting to death the virgin daughter of Agamemnon, leader of the Greek army; tormented by the gods and egged on by Odysseus, he induces his wife Clytemnestra to bring their daughter to the camp, using the false pretense that she is to marry Achilles; instead they find that the ceremony at the altar is to be the girl's death. In the ending that was possibly added after the poet's death, the goddess descends at the last possible moment to substitute a deer for the girl (whom she will carry away to the remote Black Sea region of Tauris).[3]

Whether or not Euripides wrote the final passages of the existing play, that outcome is both consistent with his intentions (in that he had already written his *Iphigenia in Tauris*, where the heroine reappears as a priestess in the temple of the Taurian Artemis) and with the most ancient known telling of the story. There is, of course, another variant in which the sacrifice is final and may even have occurred by Agamemnon's own hand. The plays on the same subject by Aeschylus and Sophocles are lost, but the summaries of events given in the former's *Agamemnon* and the latter's *Electra* assume the death of the princess as a stark fact. Aeschylus's king, maddened by lust for bloody conquest, almost revels in the deed ("Her father called his henchman on, on with a prayer, 'Hoist her over the altar like a yearling, give it all your strength!'"); and for both poets the event serves as the prefiguration of Clytemnestra's murder of her husband on his return from Troy—and then her son Orestes' murder of her in return.[4]

For the eighteenth century, this represented a more esoteric tradition when compared to the full, familiar development of the story in Euripides. Sophocles, at least in the mind of the loyal daughter Electra, makes Agamemnon more the victim of divine coercion, which would allow for the despairing posture and expression that Van Loo gives his character (fig. 28); but the miraculous ending in Euripides allowed the painter to contrast that peak of inner grief and emotional conflict with a complete transformation to come in the next moment: the very act of exposing his feelings to the viewer momentarily blinds Agamemnon to Artemis's miraculous apparition behind him.

FIGURE 28. *Carle Van Loo, study for figure of Agamemnon in* The Sacrifice of Iphigenia, *black chalk, 34.8 × 21.2 cm., Musée des Beaux-Arts, Quimper.*

This choice allowed Van Loo to enhance his painting with a greater play of contrasts and abundance of effects—not to mention a comforting uplift in its analogy to the divine salvation of the innocent Isaac—than the more brutal version of the story would have permitted: all consistent with the function and stature that he intended the work to express. But that same choice also tipped his enterprise into territory where such confident completeness could itself be construed as a profound flaw. To expose the naked expression of Agamemnon was to defy another authority, potentially greater than that of a preeminent academician or royal patron, which inhered in a few very old and very fragmentary texts about a painting that no one had ever seen. It was painted by the ancient Greek artist Timanthes of Kythnos around 400 B.C. and likewise depicted the sacrifice of Iphigenia, but with the crucial difference that Agamemnon appeared with his face veiled and hidden from view.[5]

Lost since antiquity, the reputation of the painting endured in the reports and asides of classical writers. Cicero had mentioned this work in his advice to young students of oratory, counseling them sometimes to fall silent if an emotion cannot adequately be expressed: "So the painter in representing the sacrifice of Iphigenia, after representing Calchas as sad, Ulysses as still more so, Meneleus as in grief, felt that Agamemnon's head must be veiled, because supreme sorrow could not be portrayed by his brush."[6] When the elder Pliny picked up the story in his famous chapters on the history of ancient art, he added that this was an example of Timanthes' gift for invention, that he was the only painter with the gift for making the viewer imagine more than was actually depicted.[7] The founding art theorist of the Italian Renaissance, Leon Battista Alberti, repeated the same point with even more evident approval, making it a persistent touchstone for codes of European painting.[8] Nicolas Poussin's early and extremely influential *Death of Germanicus*, from 1627, came to be celebrated in the doctrine of the French Academy of Painting for his having deftly updated the device of Timanthes: Agrippina, loyal wife of the heroic and treacherously murdered Roman hero, is marked by her having buried her face in a veil (fig. 29).[9] Johann-Joachim Winckelmann's first, highly influ-

ential treatise on the art of antiquity included a frontispiece (by Adam Friedrich Oeser) depicting Timanthes in the process of realizing his exemplary project (fig. 30).[10] Directly beneath the title, *Reflections on the Imitation of Greek Works in Painting and Sculpture*, Oeser's Agamemnon seems to stand in front of the sacrificial tableau, virtually in the same space with the artist, assiduously working from his tragic script, and with the battered antique torso to the left. Below, Winckelmann added his epigraph from Horace's *Ars Poetica* (268–69): "As to you, to Greek patterns, set your hand by day and by night."[11]

.

But there was something about this doctrine—though sanctioned by the authorities of antiquity and conducive to a dignified restraint in painting—that nevertheless attracted furious objections and even ridicule. Already by 1670, one commentator, the engraver Grégoire Huret, was writing:

[T]he impudence and bad conduct of Timanthes, who found himself unhappily at the limit of his competence at the very place where he had most need of it, and was compelled to leave his work imperfect at the place where it ought to have been the most accomplished; and all this for not having prudently . . . applied his greatest effort in representing first and foremost the face of that father, and then afterwards her closest friends and relatives. . . . [I]f you saw this painting without being told about his feeble excuse, would you not be in doubt as to whether he was laughing or weeping, or sleeping, or indeed whether he was not hiding some ulcer, of even whether it might have been the custom of the kings of those countries or of those times to go about with veils over their noses, or, in brief, some similar stupidity? Indeed, it is a good way out for ignorant painters, or those who would spare themselves trouble, to cover with similar veils all of the most difficult . . . parts of their works, so that we might assume the beauty supposedly concealed underneath.[12]

FIGURE 29. *Nicolas Poussin,* The Death of Germanicus, *1627, oil on canvas, 148 × 198 cm., The Minneapolis Institute of Arts.*

Despite the acknowledged authority of Poussin's veiled Agamemnon, the tendency of the mature Academy in France lay in the contrary direction marked out by Huret. His outburst against Timanthes was published some two years after the first delivery of Charles Le-Brun's famous lecture on the expression of the passions, which offered the artists under his direction a systematic, detailed anatomy of the outward muscular responses to nearly all the inner states of feeling that their narratives might require.[13] Some years before, when he had painted his own version of the Iphigenia subject (now lost), he had played with the tradition, showing Agamemnon in the act of placing a veil between himself and the altar while, at the same time, exposing his face to the viewer.[14] Later academicians were more overt in pressing the claims of their expressive vocabulary in treating the subject. Around 1730, Charles Coypel launched his career as a historical painter with a version (also lost) that employed the same device.[15]

FIGURE 30. *Adam Friedrich Oeser,* The Sacrifice of Iphigenia, *1755, etching, detail of frontispiece to Johann-Joachim Winckelmann,* Gedanken über die Nachahmung der Greichischen Werke in der Malerei und Bildhauerkunst, *courtesy of Yale University Library.*

When Van Loo received his commission from Frederick the Great, its terms endorsed the anti-Timanthean tradition of the French Academy, specifying that the king's face be revealed so as to manifest "the vividness of his pain expressed with all the resources of art."[16] For all that institutional and ideological support, however, the decision to expose Agamemnon's face to the viewer seemed to require a preemptory defense before it was ever attacked. Its main advocate was the comte de Caylus, the well-known antiquarian and amateur member of the Academy who wrote a thirty-page pamphlet extolling the virtues of Van Loo's efforts in advance of its exhibition. The audience thus heard from Caylus that it should be predisposed to appreciate how "the artist has hidden none of [Agamemnon's] pain; it is imprinted in every part of his face. We read in his eyes all the dejection of his soul. . . . His magnificent dress, far from undermining the expression of his

pain, makes it if anything even stronger, while leading our minds . . . to the realization of the unhappy fate of humanity, from which the pomp and majesty of the throne cannot spare the monarch."[17]

The normally decorous Caylus, renowned for his veneration of antiquity, was moved to label the Timanthes prototype "an absurdity" (thus bringing the obscure protest of Huret into the mainstream).[18] The unanswered question is what exactly gave rise to this vehemence and the apprehension that Caylus meant to conjure away.[19] Behind the dispute, seemingly pedantic and inconsequential for modern-day viewers, lay nothing less than two starkly opposed conceptions of how painting conveys meaning. One sees the expressive task of art to lie in mimicry of appearances, in contortions of facial muscles, rolling of eyes, and demonstrative pantomime, and it takes as axiomatic that this mimicry should be as full and present to vision as the painter can manage. The other assumes that expression in painting does not necessarily inhere within any of the personages that we imagine we see; instead it is a product of the relationships between them, indeed between any of the motifs or elements—animate or inanimate—that make up a painting.

The example of Timanthes served as the key to grasping this second conception in a conscious way. All of the accounts of his lost *Iphigenia*, whatever their differing emphases, imply the following logic: The painter starts at the pitch of emotion proper to the most subordinate figures in the drama; but this pitch is already very high indeed; discernible intervals leading up through the hierarchy of major actors push past the highest capacity of painting for mimicking expressive behavior; the signal achievement of the ancient painter was therefore to have discovered and marked that limit, and then further to have enlisted his discovery into the catharsis of emotion achieved by his work.

Against the views of Alberti and his followers, the success of the device is not that the viewer projects some immensity of emotion into the blank space; it is rather that the blank space is crucial for measuring the height of the progressive steps that led up to it. The ordering of emotional signs, not the mimicry of any particular point in the progression, is crucial, and that ordering of expressive intervals depends

on their being a zero point in the system, a point where measurable value is canceled. The *Iphigenia* of Timanthes served as the most potent metaphor for this abstraction. Its legend meant that the pantomime of expression in the end will fail—for a whole series of reasons, among them the fact that extreme emotional states can yield grotesque as well as magnetic qualities, that in avoiding the grotesque the painter will very likely tip over into the bland, that freezing a passing play of expression frequently yields the effect of a fixed grimace, that outward signs on the body are inherently unreliable indicators of inner states, particularly as there are conventions and styles in these things that change over time and from culture to culture.[20]

Harbingers of new critical attitudes in France brought the point home to Van Loo with a vengeance. One, after taxing the presumption of the "fanatique adorateur" Caylus for presuming to dictate his response, declared that the figure of Agamemnon "contorts his body like an actor searching for a pleasing posture (*une belle attitude*)." In place of this vain and artificial gyration, the king, the critic continued, "should have assumed a simple pose, his gaze glued to the earth, to mark the inner shame of ambition before the reproaches of nature."[21] Such disagreements emerging in the debates of the early modern period prefigure—and at a high level of self-reflection—the disputes implicit in the three art-historical inquiries considered in the three previous chapters. The Van Loo/Caylus approach to meaning in a narrative painting approximates the assumptions of traditional iconography, where the significance of any element lies in its correspondence to name or entity defined elsewhere, to which it will be more or less adequate. Schapiro had shifted the primary ground of meaning to relationships activated inside of the work, within which such conventional meanings gained deep significance only as they were mapped according to a limited set of conceptual oppositions. Lévi-Strauss and Baxandall both refined the relationship model to account for the effects of transmission and change in object-types over time. That sophistication, however, has left untouched wide areas of the art-historical profession, where the search for illustrative reference remains the norm. And more recent interdisciplinary interest in the visual arts has,

if anything, further entrenched naive thematic reading of paintings as a kind of lingua franca among the various branches of the humanities.

That kind of intellectual inertia had its anticipations in the period under scrutiny. What scandalized the Van Loo camp was the idea that success in art could entail absence, taking away visual incidents as well as accumulating them. So they cast the device of veiled Agamemnon in the language of crime and fraud. In 1772, the sculptor and writer Étienne Falconet offered his diatribe against Timanthes, protesting that the ancient artist could not be the genius Pliny claimed him to be because he never added anything to his subject. Every Greek, he said, knew his Euripides by heart, and in that playwright's drama of *Iphigenia in Aulis*, the relevant lines are these:

... when Agamemnon saw
His girl entering the grove to meet her death,
He sobbed aloud; the tears streamed down his face; he turned
His head away, and held his robe before his eyes.[22]

The point, of course, is not as definitive as he imagined it to be, in that this is not the actual moment ascribed to Timanthes' rendering of the sacrifice (Oeser's etching for Winckelmann took the same liberty).[23] But Falconet made one signal contribution to the debate in raising the relationship to drama, something that constant rehearsal of the Roman authors failed to do.

This was the point most in need of correction, as neither side of the debate over the virtue of Timanthes stands up as an account of the tragic subject matter at issue. Ascription to Agamemnon of some supreme sorrow — which both sides shared — remained an overly simple and misleading description of his deeply divided feelings at the climax of the action, one that after all assures the ultimate success of his great adventure and exercise in command. No commentator challenged Cicero's assumption that Calchas, of all people, and the utterly expedient Ulysses deserved credit for sorrow in some way akin to that of Iphigenia's flawed father. The entire dispute assumes a sentimentality foreign to the rigor of Aristotle's anatomy of the medium and to the dis-

abused comprehension of evil in all the plays that touch upon the theme. But there was a modern version of the story, surely the greatest homage to Euripides, in which the commander of the Greeks once again sails for Troy with blood on his hands: this was Jean Racine's *Iphigénie*, first performed in 1674 but part of the cultural equipment of any educated member of an eighteenth-century audience.

The impact of this particular retelling, however, was far from direct: It shows up in the work of another artist and through another narrative entirely, whereby the visual elements of the story are unbundled from Van Loo's congealed prototype and come to be reassembled in a newly critical configuration. The work was Jean-Honoré Fragonard's *Coresus and Callirhoë* (plate 10), shown in the Salon of 1765, an exhibition that became something of a showcase for renewed ambition in French patronage following the conclusion of the Seven Years' War.[24] Its maker was still in his thirties and making his first significant impact in the Salon with a work undertaken, first of all, to secure his first stage of membership in the Royal Academy. He contrived to submit as his acceptance piece a work of much larger dimensions—and conspicuously greater sophistication and virtuosity—than virtually any other eighteenth-century example. A pen-and-watercolor drawing of the exhibition by the acute draftsman Gabriel de Saint-Aubin shows the dominating canvas in place along the left-hand wall (fig. 31).

For his narrative, Fragonard sidestepped the entire repertory of tragic drama and turned instead to a brief tale related by the Greek travel writer Pausanias in the second century A.D. Listing the sights of Patrae (modern Patras) on the northern coast of the Peloponnesian peninsula, the ancient writer noted a cult statue of Dionysus brought originally from the abandoned city of Calydon, an object with a lurid legend attached to it:

One of the Calydonian priests of the god [he related] was Coresus: love never inflicted any worse injustice on a man. . . . [I]n love with a young girl called Callirhoë, . . . the more he loved her the more he revolted her. . . . [T]he girl's feelings could not be altered: so he went and beseeched the statue of Dionysus. . . . [A]t once all of the

FIGURE 31. *Gabriel de Saint-Aubin,* View of the Salon of 1765, *black chalk, ink, and watercolor, 24 × 46.7 cm., Musée du Louvre, Paris, ©Photo RMN.*

Calydonians seemed to become raving drunk and died insane, . . . then the oracle of Dodona told them this was the vengeance of Dionysus and there was no way out until Coresus had sacrificed to the god either Callirhoë or someone who would undertake to die in her place. . . . [S]he fled to her parents, [but] even they failed her, [and] there was nothing for her to do but be slaughtered. . . . [B]ut it was to love and not to fury that [Coresus] submitted, and he made away with himself in her place. It was the greatest example in the history of sincerity in the passion of love.[25]

Shamed and transformed by the priest's action and her terrible understanding of his devotion, Callirhoë withdraws and cuts her own throat in pity and shame.

That is all there is to it: the bare skeleton of a story compared to the rich prior elaboration of the sacrifice of Iphigenia—and one almost never depicted before this thirty-two-year-old painter took it up and conceived his tableau of the stricken priest's moment of self-immolation.[26] The Coresus story had been the theme of one minor tragedy at the beginning of the century (of the kind that offered all

sorts of invented complications and subplots); it also served as the template for an opera in 1712; but no firm story line or familiar set of characters had ever been planted in the public mind.[27] While the convincing impact of Fragonard's first intervention in the arena of history painting could not be denied, the normal frame of critical reference seemed to disintegrate in front of it. The great enlightenment figure Denis Diderot, for one, writing his critical review of the Salon, acknowledged how thoroughly Fragonard had disabled conventional responses by writing a long account of the picture while pretending never to have seen it at all. In a fictional dialogue with his editor, Melchior Grimm, he related a bizarre dream, one that mimicked Plato's parable of the Cave: the hapless, manacled victims of the charlatan's shadow play, he related, believed themselves to be witnessing scenes from a terrifying story of divine madness and expiatory self-sacrifice; at the end of his narration, Grimm intervenes to inform him that the climax of the events he describes is exactly the scene depicted by the young Fragonard.[28]

Diderot thus grandly sidestepped the problem of interpretation-as-substitution with which this book began, that is, by declaring that he had never had the object in view. That rhetorical evasion in itself reveals how thoroughly Fragonard had carried out his transformations and thus rendered the existing critical vocabulary mute, even for its most gifted and freely innovative practitioner. But it may be that Diderot too quickly gave up the search for a comprehensible pedigree behind the *Coresus and Callirhoë*, for the line of descent from the looming precedent of Iphigenia's sacrifice led as surely to Racine as it did to Van Loo. There was no way, within this network of relationships, that example of the playwright's *Iphigénie* could be suppressed. And the hook on which Racine is caught, in the transsexual passage between Iphigenia and Coresus, is the change-over from one victim to two.

.

Racine, like Fragonard after him, had been trawling through Pausanias for a device with which to enact his rivalry with Euripides, and

found in the ancient writer's description of Corinth the remark that Helen of Troy had been the lover of none other than Theseus, that is, before she married Meneleus and was abducted by Paris. Moreover, in this version of events from a lost text by the Archaic-period poet Stesichorus, she had secretly borne a daughter to the Athenian hero, whom she gave as a baby to Clytemnestra, already married to Agamemnon. Other authorities too, relates Pausanias, "agree with the Argives that Theseus' daughter was Iphigenia."[29]

Racine took this fugitive variant of the story to create not one but two Iphigenias. The legitimate daughter of Agamemnon and Clytemnestra, with all her selfless obedience to her father's requirements, remains at the center of the story. But the other one enters the plot under the invented name of Eriphile, brought to the camp as a captive by Achilles and befriended by the princess, who is, unbeknownst to anyone, her illegitimate cousin and namesake. Eriphile, also in love with Achilles and despairing at the prospect of his marriage, steps forward at the last moment to seize the knife and stab herself in the breast.

Racine thus contrives an event that spares the first Iphigenia without the need for any intervention by the goddess Artemis—that sort of stage business, he claimed in his preface to the script, would have seemed outlandish and unconvincing to modern French viewers.[30] He misleads his readers somewhat in that preface by also claiming that Pausanias sanctions the existence of two Iphigenias, when the ancient text in fact asserts no such thing. The doubling is entirely Racine's invention, but his liberty with the ancient sources in fact allows him to recover the more disabused and disturbing mythology of the House of Atreus as found in Aeschylus and Sophocles.

Racine's dramatic success—and somewhat disingenuous rationalization for it—is part of an established and honorable tradition of rivalry with antiquity. The literary point of departure for narrative painting, at least on Fragonard's level, is neither one text nor a mix-and-match combination of texts; it is rather a set of relations between them. Trying to understand a painting on the basis of a one-to-one correspondence to a literary source is like trying to build a table with

just two legs. The relationship between Racine and Euripides thus inserts itself into the relationship between Fragonard and Van Loo. Unlike Racine, however, the younger painter is blocked from taking up the great theme of Iphigenia himself. There are various likely reasons for this: a direct challenge to such a recent, manifesto-like painting by the most senior man in the Academy would have been viewed as impertinent (events underscored the point when Van Loo, having ascended to the office of First Painter to the King in 1763, died a few months before the opening of the 1765 Salon); Fragonard's canvas was already overambitious for an acceptance piece, and he needed the approval of the old guard for his membership. He could moreover have had very little appetite for putting himself in the way of the endless, sterile bickering over a revealed or concealed Agamemnon, with its pedantic obsessions over exact correspondences to a literary source. If nothing else, his intended audience would have been exhausted by the repetition.

That debate had, of course, revolved around the duality of presence and absence: on or off, you see it or you don't. The Euripides-Racine relation revolved instead around the contrast between the single and the double; and it is that relation that allowed Fragonard both to express and to disguise his challenge to Van Loo. The story of Coresus and Callirhoë was waiting there for him, barely a sketch with minimal detail, onto which he could project Racine's transformation of the Iphigenia mythology.[31] (In his scanning of Pausanias's text, Fragonard could well have been encouraged in this by the passage that immediately precedes the tale of the doomed priest: it is a description of a cult statue of Artemis to which, every year in its city of origin, the most beautiful maiden and the most beautiful male youth had once been sacrificed.[32])

Is there then some manifest sign of the rivalry established by Racine making an appearance in the outcome of Fragonard's painting, that is, of Racine's transformation of Euripides exerting pressure in turn on Fragonard? The answer lies in what has always been one of the most striking and puzzling characteristics of the painting. When Fragonard first conceived the subject, as documented in one highly finished oil

study (plate 11), he imagined the high priest Coresus as a venerable bearded figure exactly like the traditional appearance of Calchas, the high priest of Agamemnon's army. The priest's bond with the terrifying power of the god Dionysus is figured in the prominence of the cult statue in the middle ground. In the final canvas, however, the cult statue has disappeared and Coresus has migrated in his appearance to an ambiguous beauty coming as near to a female appearance as his role allowed—and perhaps much nearer than that (fig. 32). As he shifts sides from the position of the vengeful god to his victim, becoming the voluntary double of the innocent maiden offered up by her community, he becomes as much like her as the means of painting permit. In place of Dionysus backing his priest is a flying genius of vengeance and anger, who overarches the two figures together, and to whom clings a small Amor.[33] Even the contrast in their dress and undress is a means of identity: she is uncovered for the knife; he is maximally covered, but Fragonard manipulates the priestly robes in their pirouetting movement to mimic a fullness of female form and thus echo the sexual position conversely revealed in the nudity of his double.[34]

A collapse of sexual and age distinctions in the main actors (and Diderot saw the acolytes too as "hermaphrodites"[35]) has as its counterpart a breakdown in meaningful differentiation of feeling. The most penetrating moment in Diderot's long, capricious commentary on the painting comes when he starkly observes, in a fierce jab at Rousseau: "Human beings, endowed as we are with innate compassion, seek out cruel spectacles in order to exercise this virtue."[36] Here, at least, he responds directly to what he sees and paraphrases an idea already realized by the painter. Fragonard, in substituting two for one, releases his figures from any stepwise participation in grief over the sacrifice; in their place is undifferentiated shock and excitement. While their expressions vary by age and sex, one has no idea what these anonymous witnesses might have felt before the event or how they might be transformed after it. Diderot (ventriloquizing in the voice of his editor and interlocutor Melchior Grimm) gave eloquent expression to this quality and, going further, extended the thought to encompass the moderate philosophe's nightmare of the passions of

FIGURE 32. *Jean-Honoré Fragonard,* Coresus and Callirhoë, *detail, Musée du Louvre, Paris.*

the populace emancipated without limits: "Wherever one's eyes settled they encountered fright. It was in every figure: it emanated from the high priest, it spread, it was intensified by the two demons, by the dark clouds accompanying them, by the somber glow of the braziers. It proved impossible to keep one's soul at a distance from an impression repeated in this way. It was like popular uprisings in which the passion of the majority takes hold of you before its cause is known."[37]

.

The process of thought that followed from Van Loo's *Sacrifice of Iphigenia* also comprises an equal and opposite counterpart to Fragonard's *Coresus* in the similarly manifesto-like sensation of two Salons before: the *Village Bride* (or *Marriage Contract*) of 1761 by Jean-Baptiste Greuze (fig. 33). Fragonard had taken the theme of mortal sacrifice and divorced it from family bonds (his heroine finds herself an outcast when she turns to her family for help); in the process he collapsed the legible gradations of emotion assumed in his prototype. Greuze, by contrast, assiduously preserved those gradations within a family hierarchy, but did so by jettisoning the idea, essential to tragedy and as old as Aristotle, that moral profundity entailed sacrificial pain and the tearing of familial bonds. Where Fragonard offered sacrifice without the family; Greuze had proposed the family without sacrifice—and did so in a way commensurable with the most ambitious historical painting.

In terms of time, place, social standing, and plausible actuality, Greuze's household may be a world away from the scene of the bloody descendants of the house of Atreus, but he has retained a remarkable list of traits corresponding to key constituents of Van Loo's *Sacrifice of Iphigenia*. At the summit of a compositional pyramid, a young woman clad in white is handed over by her father to a servant of the state bent on his duty, which is to seal her separation from the family circle. Her tearful mother, like Clytemnestra, collapses to her seat and clings weakly at the last moment in sorrow at the loss of a nurtured child and her irrevocable change in state. The expansive gesture of the father exists in roughly the same proximity to his departing daughter. The

FIGURE 33. *Jean-Baptiste Greuze,* The Village Betrothal, *1761, oil on canvas, 92 × 117 cm., Musée du Louvre, Paris.*

defining difference is that Greuze's young Achilles moves from the excluded margin to the center. So the falsehood of marriage between the mythic lovers, the pretext of blood sacrifice, becomes instead a believable contemporary event.

That repairing of the breached promise, the substitution of harmony and happiness for murderous discord, necessarily moves it from the legendary realm occupied by the Van Loo. One could argue in return that Greuze at this time was capable of nothing else but the depiction of contemporary types. But it was this extraction of the family from its classical matrix, while at the same time retaining the highly abstract configuration of momentous life transformation, that permitted him to undertake this quantum transformation of his genre materials into something his contemporaries perceived as refined and rare. In the process, he managed to preserve Van Loo's and Caylus's finite calibration of role and position, but doing so required a whole

series of reversals: of a high genre on an imposing physical scale to a middling one in modest dimensions, of antiquity to the present, of noble to common, and of suffering to happiness. Fragonard, conversely, succeeded in credibly perpetuating large-scale drama of pain and suffering set in the ancient world, but found himself overturning the scales of emotions to reveal an underside of undifferentiated pandemonium, of contagious shock and panic. The splitting of Van Loo's attempt at high tragedy produced paintings that transcended their apparent disparity of genre to comprehend a profound difficulty in the secular theory of virtue as it took over from religious piety; each spells out one side—positive or negative—of the Enlightenment project: the utilitarian arithmetic of happiness in Greuze is counterbalanced by the emancipation of cruelty and the objectification of unredeemed suffering in Fragonard.

While each artist was thus able to transform Van Loo's backward-looking set piece into a striking expression of modernity, neither was able to continue much or any further in this vein: Greuze soon found dreams of happiness an insufficient foundation for narrative and turned to more conventional dramatic conflict; for his part, Fragonard stopped dead in his tracks and never undertook another history painting for the Salon again in his life. And neither of them discovered a new approach to the moral grandeur of tragedy. For that to happen, family and sacrifice needed to be rejoined, but in a painting of relations that took seriously the true lessons of the Timanthes legend. If one imagines a triangular pattern whereby Van Loo's *Iphigenia* at the top divides into the *Village Bride* and *Coresus* to form the points of the base; then those two lateral points must be made to converge again at the bottom to form a diamond shape. That point of convergence can be signaled in one question: What happened to the veiled Agamemnon?

The motif by no means disappeared in discredited shame; it triumphantly reappeared in the last great painting of mortal sacrifice produced under the Old Regime in France: Jacques-Louis David's *Lictors Returning to Junius Brutus the Bodies of his Sons* (fig. 34), shown in the Salon of 1789, when the shouts of the destroyers of the Bastille still

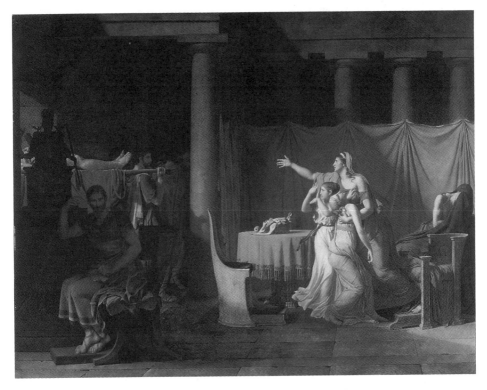

FIGURE 34. *Jacques-Louis David,* The Lictors Returning to Brutus the Bodies of His Sons, *1789, oil on canvas, 323 × 422 cm., Musée du Louvre, Paris*

reverberated in the surrounding streets. The master of the house, one of Rome's first Consuls and the drafter of its republican laws, has just ordered and witnessed the beheading of his sons for plotting to return the corrupt and hated monarchy to power. With it David produced his manifesto of a philosophy of painting in which emotions work on the viewer through a calculus of relationships rather than through pantomimes of feeling. Only the mother and sisters to the right of the scene's empty center display their shock and grief at the entry of the horrifying cortege (the sight of which has propelled them from their seats around the table); but any promise of emotional verisimilitude is constrained within their highly formalized, profile arrangement. Brutus, sheltering beneath the statue of Roma and guarding himself from the sight of the corpses, shows no discernible state of feeling at all. The

eloquence of the painting lies in the stretched space between them (uninhabited except for a poignantly mute basket of sewing) and, as counterpoint, the face of a profoundly grieving figure hidden from the viewer by a veil (plate 12). This is the aged woman, marked by her corded neck and sinewy, sun-browned arms, whom one takes to be the nurturer of the boys in their youth.

In this latecoming depiction of a ruler who sacrifices his offspring under the public pressure of duty there prevails a conservation of thematic matter from the ancient prototype of Agamemnon and Iphigenia, but that survival entails profound reversals in the status of the chief mourner: from male to female, from the heart of the action to its furthest edge, from the highest rank to the lowest. She is accorded the honor of deepest and most admirable grief—a powerful statement of incipient democracy in the year when the French Revolution began. And, more than that, by shifting the accolade of supreme sorrow away from the father, leaving his implacable denial of love exposed as *no* expression, it expunges the sentiment and the compromise of tragedy from Timanthes' lauded conception of the sacrificial murder of a child.

.

The attempt in this chapter, as a postscript to the previous three, has been to offer at least a snapshot of artistic thought, the intelligence of art in the making. Art historians have become adept at interpreting meaning in works of art after the fact, but much less so in finding any map to follow how thoughts form, how existing references and circumstances are reconfigured to give artist and audience something new to feel and comprehend. Too much theoretical emphasis on the fixed, contemplative gaze has also left the discipline poorly equipped to follow the logic of change in a given set of circumstances—the understanding of change being the essence of any historical project. The kinds of analyses offered by Schapiro, Lévi-Strauss, and Baxandall not only suggest what such a map might look like; they also make it plain that the rarity of such insight should come as no surprise, that exceptional works of art made under circumstances of exceptional volatility are the ones likely to yield that information. Understanding depends

upon generalization, but any tendency to generalize on the basis of the superficially typical or normative will obscure access to the inner processes by which a work of art takes on its final form.

In each case, the key has been to find a gap, a zero point, or a disruptive substitution taking place inside a work of art from which issues a continual turning over or transformation of its defining elements. At Souillac, where devil and apostate replace Christ in majesty, the disturbance arises from violence done to an established norm; with the masks of the Salish and Kwakiutl, the passage of forms across cultural thresholds selectively blocks or reverses the transmission of distinctive features; even catastrophic destruction, as in the iconophobias of the Reformation, can generate the proof that an object bears within it the deepest, irresolvable contradictions of a society.

There have been and will be, of course, many other ways to grasp the infinitely complex operations of human intelligence in artistic form; the model extracted from these examples is a heuristic device, not a comprehensive psychology. It offers the advantage, however, of emerging from concrete studies that recommend themselves as best practice for many other reasons. And their strongest recommendation is that they exist; they are already well down a road of understanding. Few of those currently bidding for our attention as arbiters of methodology can make the same claim, particularly those whose models come unmodified from other disciplines of thought. Too many years have already been consumed in marking time, in speculating on possible courses of action, in finding high-sounding reasons for not answering, as historians of art, the invitations inscribed in the most extraordinary physical remains of human history.

NOTES

CHAPTER ONE

1. The emphasis within this approach on tracing themes and variations converged with another tendency, one peculiarly powerful in postwar America. This was the curious translation of an earlier preoccupation in German scholarship with esoteric theology and philosophy as encoded in visual symbols during the Renaissance. Unchecked by genuine erudition, certain art historians in North America pursued tenuous and conjectural associations spiraling away simultaneously from documented textual references and from any plausible notion of human agency in the fashioning of the art.

2. From an interview with James Thompson and Susan Raines, "A Vermont Visit with Meyer Schapiro (August 1991)," *Oxford Art Journal* 17, no. 1 (1994).

3. Meyer Schapiro, "From Mozarabic to Romanesque in Silos," *Art Bulletin* 21 (1939): 312–74; reprinted in Schapiro, *Romanesque Art: Selected Papers* (New York: Thames and Hudson, 1993), 28–101. Schapiro, "The Sculptures of Souillac," in *Medieval Studies in Honor of Arthur Kingsley Porter*, ed. W. R. W. Kohler (Cambridge, Mass.: Harvard University Press, 1939), 359–87; reprinted in Schapiro, *Romanesque Art*, 102–30.

4. See the recent study by Kathryn Brush, *The Shaping of Art History: Wilhelm Vöge, Adolph Goldschmidt and the Study of Medieval Art* (Cambridge and New York: Cambridge University Press, 1996).

5. Arthur Kingsley Porter, "Art, Caviar, and the General," *The Yale Review* 7 (1918): 592, 611.

6. For an invaluable and brave discussion of this dimension of Porter's career, see Nora Nercessian, "In Desperate Defiance: A Modern Predicament for Medieval Art," *Res: Anthropology and Aesthetics* 7–8 (Spring/Autumn 1984): 137–46.

7. See Linda Seidel, "Arthur Kingsley Porter: Life, Legend, and Legacy," in *The Early Years of Art History in the United States*, eds. C. H. Smyth and P. M. Lukehart (Princeton, N.J.: Dept. of Art and Archaeology, Princeton University, 1993), 103.

8. Ibid., 108–9.

9. See Meyer Schapiro, "The Social Bases of Art," in *Proceedings of the First Artists Congress against War and Fascism* (New York, 1936), 31–37.

10. "The State which encourages the herd instinct, which imposes a graduated income tax, which transfers property by force from a man who has it to a man who hasn't, is a thief" (Porter, Harvard University lecture, 1932, quoted in Nercessian, "In Desperate Defiance," 144).

11. On the estate, see John Cornforth, "Glenveagh Castle, Co. Donegal, the Home of Mr Henry P. McIlhenny," *Country Life* 171 (3 June 1982): 1636–40.

12. I owe this information to the insightful unpublished thesis of Hadley Soutter, "Intellectual Development in Meyer Schapiro's Writing, 1929–1939," which draws on her interview with Schapiro in 1986.

13. See W. Smith and H. Wace, eds., *Dictionary of Christian Biography* (London: John Murray, 1880–87), 2:413, 4:1009. By the twelfth century, the story had been widely copied in manuscripts and there were many shorter versions and a number of poems extant. The Theophilus tale served as a frequent illustration in sermons and, since the eleventh century, had been included in the Liturgy of the Office of the Virgin as an instance of her mercy and mediation in the lives of penitential sinners. For a summary of this literature and the history of scholarship on the Theophilus legend, see Carol Knicely, "Decorative Violence and Narrative Intrigue in the Romanesque Portal Sculptures at Souillac" (Ph.D. diss., University of California, Los Angeles, 1992), 46–71.

14. Arthur Kingsley Porter, *The Virgin and the Clerk* (Boston: Marshal Jones Company, 1929).

15. In the story as recounted by Paul the Deacon, a Jew serves as intermediary in introducing Theophilus to the Devil. See Knicely, "Decorative Violence and Narrative Intrigue," 50.

16. The only earlier known illustration of the story is in a single decorated initial from one of the manuscripts of the Theophilus legend from the eleventh century (see Schapiro, "Sculptures of Souillac," 110, for an illustration). Almost all of the other representations of the story date from a century later than Souillac (see Knicely, "Decorative Violence and Narrative Intrigue," 48–49).

17. See note 3.

18. Schapiro, "Sculptures of Souillac," 102–3; he acknowledges, while judging it "highly improbable," that "the sculpture of Theophilus perhaps was not an accessory relief beside a larger, more emphatically centralized sculpture of Christ or the Virgin in Glory." That hypothesis was recently revived by Jacques Thirion, in "Observations sur les fragments sculptés du portail de Souillac," *Gesta* 15 (1976): 161–72, to which Régis Labourdette has made a persuasive reply, based on further archaeological evidence and interpretation, that fundamentally supports Schapiro's original assumptions (see "Remarques sur la disposition originelle du portail de Souillac," *Gesta* 18, no. 2 (1979): 29–35). Labourdette calls the monument "a structural condensation of a porch." He takes into account data such as the dimensions of the church tower, which is too small to sustain an external porch on the order of its sister portal sculptures at Moissac and Beaulieu, and there is no evidence that one ever existed. Absence of weathering indicates that the sculptures have been inside since a very early date, and the lack of damage from handling suggests that they were always high enough to be out of reach (the commanding attitude of the flanking saints is also inconsistent with a lower, porch position). Only the

large figured pillar appears to belong to a larger, uncompleted scheme, where it might have functioned as a central trumeau supporting a tympanum. "Consequently," Thirion concludes (34), "it can be hypothesized that the trumeau belongs to the original conception for a large ensemble which was then abandoned. The trumeau was then adapted to a location for which it was not planned. The little fragment of a pier was a pendant to it, however poorly it is integrated into the whole. The dimensions of the sculpture of Theophilus are acceptable for a high position above a tower door, while they would have been overpowering in a lower position to one side."

19. Schapiro, "Sculptures of Souillac," 119.
20. Ibid., 103.
21. Ibid., 110.
22. Ibid.
23. Ibid., 104.
24. Ibid., 116.
25. Ibid., 123.
26. Ibid., 108–9.
27. Schapiro, "From Mozarabic to Romanesque in Silos," 38, 74–79.
28. Schapiro, "Sculptures of Souillac," 111–12.
29. Ibid., 119.
30. On the considerable amount of information to be gleaned from documents surviving elsewhere in the region, particularly those from or about the mother abbey of Aurillac, see Knicely, "Portal Sculptures at Souillac," 345–46.
31. Schapiro, "Sculptures of Souillac," 122.
32. Knicely, "Decorative Violence and Narrative Intrigue," has recently demonstrated that it is possible to parallel Schapiro's feat on the level of explicit Christian thematics while holding in mind the novelty and multivalency of the monument and avoiding the trap of an iconographical source hunt. I cannot do justice here to the persuasive range and complexity of her interpretation, which considers the portal complex in nearly every communicative aspect. Her stress on what she calls "thematic reversal" of developed biblical and secular themes makes it now a necessary expansion of and complement to Schapiro's analysis, which concentrates on reversals of elementary traits and positions.

CHAPTER TWO

1. See Claude Lévi-Strauss, *Tristes Tropiques*, trans. J. and D. Weightman (New York: Atheneum, 1981), 17–36.
2. Lévi-Strauss, preface to Roman Jakobson, *Six Lectures on Sound and Meaning*, trans. J. Mephan (Sussex: Harvester, 1978), xi.
3. Ibid., 61–62.
4. Ibid., xvi.
5. Ibid., xii.
6. Lévi-Strauss, "New York in 1941," in *View from Afar*, trans. J. Neugroschel and P. Gross (Oxford: Basil Blackwell, 1985), 262.

7. Ibid.

8. Originally published in English in *La Gazette des Beaux-Arts;* partly reprinted in French in Lévi-Strauss, *La Voie des masques* (Geneva: Albert Skira, 1975), 7–27; translated in Lévi-Strauss, *The Way of the Masks,* trans. S. Modelski (Seattle: University of Washington Press, 1982), 3–8.

9. "La Nature est un temple où de vivants piliers / Laissent parfois sortir de confus paroles; / L'homme y passe à travers des forêts de symboles / Qui l'observent avec des regards familiers."

10. See Marshall Hyatt, *Franz Boas, Social Activist* (Westport, Conn.: Greenwood, 1990), 3–13; also Aldona Jonaitis, *From the Land of the Totem Poles: The Northwest Coast Indian Art Collection at the American Museum of Natural History* (Seattle: University of Washington Press, 1991), 122–24.

11. See Hyatt, *Franz Boas,* 18–22, 42–45.

12. For a recent discussion of Boas's approach, see Ira Jacknis, "Franz Boas and Exhibits: On the Limitations of the Museum Method of Anthropology," in *Objects and Others: Essays on Museums and Material Culture,* ed. G. Stocking (Madison: University of Wisconsin Press, 1985), 75–111.

13. Lévi-Strauss, *Way of the Masks,* 3.

14. Ibid., 3–4.

15. Ibid., 7–8.

16. Ibid., 5.

17. Ibid., 4.

18. Claude Lévi-Strauss, *Le Cru et le cuit* (Paris: Plon, 1964); translated as *The Raw and the Cooked,* trans. J. and D. Weightman (New York: Harper and Row, 1969); *Du Miel aux cendres* (Paris: Plon, 1966); translated as *From Honey to Ashes,* trans. J. and D. Weightman (New York: Harper and Row, 1973); *L'Origine des manières de table* (Paris: Plon, 1968); translated as *The Origin of Table Manners,* trans. J. and D. Weightman (New York: Harper and Row, 1978); *L'Homme nu* (Paris: Plon, 1971); translated as *The Naked Man,* trans. J. and D. Weightman (New York: Harper and Row, 1981).

19. Lévi-Strauss, preface to Jakobson, *Six Lectures,* xxiv.

20. Lévi-Strauss, *Way of the Masks,* 5.

21. Ibid., 12, 10.

22. Ibid., 39.

23. According to Jay Powell, there is endemic confusion in the earlier literature between the many related groups speaking the Kwak'wala language and the specific, much studied Kwakiutl from the area of Fort Rupert on Vancouver Island. On this point, see "The Kwak'wala Language," in *Kwakwaka'wakw Settlements,* ed. Robert Galois (Vancouver: UBC Press, 1994), 13–14.

24. Lévi-Strauss, *Way of the Masks,* 40.

25. Ibid., 57.

26. See Sergei Kan, *Symbolic Immortality: The Tlingit Potlatch of the Nineteenth Century* (Washington: Smithsonian Institution Press, 1989), 240–46.

27. See Franz Boas, *Kwakiutl Ethnography,* ed. H. Codere (Chicago: University of Chicago Press, 1966), 93–94.

28. I follow here the critical synthesis provided by Philip Drucker and Robert F. Heizer, *To Make My Name Good: A Reexamination of the Southern Kwakiutl Potlatch* (Berkeley: University of California Press, 1967).

29. See Franz Boas, "The Social Organization and Secret Societies of the Kwakiutl Indians," *Report of the U.S. National Museum for 1895* (1897), 479.

30. This simple hypothetical model must now be set within the far more learned and complex interpretation of the themes at Souillac by Carol Knicely, "Decorative Violence and Narrative Intrigue in the Romanesque Portal Sculptures at Souillac" (Ph.D. diss., University of California, Los Angeles, 1992). One of the many strands of her analysis is to trace the posture of the fierce lions and griffins on the trumeau to prototypes in which guardian, subjugated, and/or adoring beasts appear as flanking companions to powerful individuals, both secular and religious. The Apocalyptic retinue of the enthroned Christ is just one instance of this, which also includes, more appositely, Daniel in the Lion's Den from the Old Testament and, from medieval romance, Alexander the Great borne toward heaven by two tamed griffins (the latter hero being a model for the good king among the elite laity) (200–206). Taken together, as Knicely demonstrates, the two themes link triumph over death (prefiguring Christ's descent into Hell) with a near-apotheosis. The reversal of this synthesis in the Souillac trumeau yields the lesson of an imperiled soul without confidence in salvation, understandable within a tradition traced to Gregory the Great, whereby the soul at the moment of death is in danger of being carried away by agents of the Devil, beasts made ravenous by "the bait of sin" (323). Her imaginative and convincing recasting of iconographical research, which goes much further than this small sample, entails alertness to the power of "thematic reversal" to generate comprehensible meaning of sufficient suppleness and novelty to respond to complex thought and changing function, a level of signification not reducible—as is customary in this area of art history—to strict identities between represented personages or events.

CHAPTER THREE

1. Kurt Seligmann, "Entretien avec un Tsimshian," *Minotaure*, no. 12–13 (Spring 1939): 66–69; and "Le Mat Totem de Gédem Skanish," *Journal de la Société des Américanistes* 31 (1939): 121–28; for a discussion, see Martica Sawin, *Surrealism in Exile and the Beginning of the New York School* (Cambridge, Mass.: MIT Press, 1995), 23–26.

2. Seligmann, "Le Mat Totem," 67. Seligmann did not recognize or acknowledge that during the period in which he made his visit, older Tsimshian were promoting a revival of traditional ceremony and placing a more assimilated and secularized younger generation under considerable pressure to participate; some of the latter were opposed to spending money on poles and wanted the rituals shortened and modernized. See Douglas Cole and Ira Chaikin, *An Iron Hand upon the People: The Law against the Potlatch on the Northwest Coast* (Seattle: University of Washington Press, 1990), 152–54.

3. See Claude Lévi-Strauss, *The Way of the Masks*, trans. S. Modelski (Seattle: University of Washington Press, 1982), 226–27.

4. See Franz Boas, citing the family traditions recorded by his informant George Hunt, in "Ethnology of the Kwakiutl," *Bureau of American Ethnology Annual Report*, no. 35 (1921), 891–938.

5. See Sergei Kan, *Symbolic Immortality: The Tlingit Potlatch of the Nineteenth Century* (Washington: Smithsonian Institution Press, 1989), 241, who summarizes a body of earlier literature.

6. See Philip Drucker and Robert F. Heizer, *To Make My Name Good: A Re-examination of the Southern Kwakiutl Potlatch* (Berkeley: University of California Press, 1967), 23–26, 42–47, and Douglas Cole, "The History of the Kwakiutl Potlatch," in *Chiefly Feasts: The Enduring Kwakiutl Potlatch*, ed. A. Jonaitis (Seattle: University of Washington Press, 1991), 135–36.

7. See Drucker and Heizer, *To Make My Name Good*, 53–80.

8. See Franz Boas, *Kwakiutl Ethnography*, ed. H. Codere (Chicago: University of Chicago Press, 1966), 84.

9. Cole and Chaikin, *Iron Hand*, have written a superbly detailed and balanced account of this entire episode, which contains much valuable information on modern potlatching along the way; see also Drucker and Heizer, *To Make My Name Good*, 31–33.

10. See Cole, "History of Kwakiutl Potlatch," 140–66; Cole and Chaikin, *Iron Hand*, 140, also describe the exceptional, rich traditionalism that prevailed in one remote Kwakwaka'wakw fastness at Kingcome, including exceptional mask carving by Willie Seaweed and the exchange of two Coppers in 1939 for thousands of blankets and goods.

11. See Boas, *Kwakiutl Ethnography*, 54–55; Cole and Chaikin, *Iron Hand*, 75–83.

12. Michael Baxandall, *The Limewood Sculptors of Renaissance Germany* (New Haven: Yale University Press, 1980).

13. Ibid., 12.

14. Ibid., 27–48.

15. Ibid., 42.

16. Ibid., 62.

17. Ibid., 67.

18. It may be that this ironization of out-of-date concepts lapses in some of his discussion, particularly in instances where German sculptors worked well to the east, in contact with thriving Polish and Hungarian centers of sophisticated artistic culture. See the telling points concerning Veit Stoss in Cracow made by Thomas DaCosta Kaufmann, in *Court, Cloister and City: The Art and Culture of Central Europe* (London: Weidenfeld and Nicolson, 1996), 77–95.

19. For an account of these conditions and a discussion of the historical debate over the nature of pre-Reformation piety, see Steven E. Ozment, *The Reformation in the Cities: The Appeal of Protestantism to Sixteenth-Century Germany and Switzerland* (New Haven: Yale University Press, 1975), 1–46. On the symbiotic relationship between iconophilia and iconophobia, see Christo-

pher Wood, "In Defense of Images: Two Local Rejoinders to the Zwinglian Iconoclasm," *The Sixteenth Century Journal* 19 (Spring 1988): 25–44, and "Ritual and the Virgin on the Column: The Cult of the Schöne Maria in Regensburg," *Journal of Ritual Studies* 6 (1992): 87–101.

20. See Carol Knicely, "Decorative Violence and Narrative Intrigue in the Romanesque Portal Sculptures at Souillac" (Ph.D. diss., University of California, Los Angeles, 1992), 310–13.

21. Baxandall, *Limewood Sculptors*, 92.

22. Ibid., 75; for further amplification, see Carl C. Christenson, *Art and the Reformation in Germany* (Athens, Ohio, and Detroit: Ohio University and Wayne State University Presses, 1979), 66–109, 164–80.

23. Baxandall, *Limewood Sculptors*, 78; for an extensive, abundantly documented (and more positive) account of these genres of sculpture, see Jeffrey Chipps Smith, *German Sculpture of the Later Renaissance* (Princeton: Princeton University Press, 1995).

24. Baxandall, *Limewood Sculptors*, 78.

25. Ibid., 92.

26. Ibid.

27. Ibid., 188–89.

28. Ibid., 10.

CHAPTER FOUR

1. This phenomenon is the broad theme in Thomas Crow, *Painters and Public Life in Eighteenth-Century Paris* (New Haven and London: Yale University Press, 1985). Left to one side here will be the contrary phenomenon, far more indirect in its effects on Salon art, whereby unmet needs found expression in unsanctioned and politically charged forms of religious observance.

2. For further detail on this paradoxical project, see H. Fullenwider, "'The Sacrifice of Iphigenia' in French and German Art Criticism, 1755–57," *Zeitschrift für Kunstgeschichte* 52 (1989): 539–49.

3. On the status of the ending and its relation to earlier instances of animal substitution in the myth, see Maria Holmberg Lübeck, *Iphigenia, Agamemnon's Daughter* (Stockholm: Almsquist and Wiskell International, 1993), 28–30.

4. Aeschylus, *Agamemnon*, in *Aeschylus: The Oresteia*, trans. R. Fagles (London and New York: Penguin, 1977), 111. For a succinct, careful examination of the early variants of the myth, see Lübeck, *Iphigenia*, 3–36.

5. The intellectual posterity of this legendary painting has recently been the subject of a thorough synthetic account by Jennifer Montagu, entitled "Interpretations of Timanthes's *Sacrifice of Iphigenia*," in J. Onians ed., *Sight and Insight: Essays on Art and Culture in Honour of E. H. Gombrich at 85* (Oxford: Phaidon, 1994), 305–26; all of the texts cited below are reviewed by Montagu, along with more that cannot be included within the confines of this chapter. See also Fullenwider, "'Sacrifice of Iphigenia.'"

6. See Cicero, *Orator*, trans. H. M. Hubble (Cambridge, Mass.: Loeb Classical Library, 1939), 360–61.

7. Pliny the elder, *Natural History*, vol. 9, trans. H. Rackham (Cambridge, Mass.: Loeb Classical Library, 1984), 315.

8. *Leon Battista Alberti on Painting*, trans. J. R. Spencer (New Haven: Yale University Press, 1966), 78.

9. See André Félibien, *Entretiens sur les vies et sur les ouvrages de plus excellens peintres anciens et modernes*, vol. 3 (Trévoux, 1725), 221–22.

10. Johann-Joachim Winckelmann, *Gedanken über die Nachahmung der Greichischen Werke in der Malerei und Bildhauerkunst* (Dresden, 1755; second, enlarged edition, Dresden and Leipzig: Im Verlag der Waltherischen Handlung, 1756). Both editions included Oeser's engraving.

11. Horace, *Satires, Epistles and Ars Poetica* (Cambridge, Mass.: Loeb Classical Library, 1926), 472; trans. Fullenwider, "'Sacrifice of Iphigenia,'" 541.

12. Grégoire Huret, *Optique de portraiture et peinture* (Paris, 1670), 105; quoted in Montagu, "Interpretations," 312–13.

13. On the complicated question of their date—and the errors in the previous art-historical literature—see Jennifer Montagu, *The Expression of the Passions: The Origin and Influence of Charles Le Brun's "Conférence sur l'Expression Générale et Particulière"* (New Haven: Yale University Press, 1994), 141–43. Montagu provides the only reliable text in both French and English translation, 109–40.

14. For a discussion, see Montagu, "Interpretations," 310–12.

15. In 1757 Friedrich Melchior Grimm, in Grimm et al., *Correspondance littéraire, philosophique et critique*, vol. 3, ed. M. Tourneux (Paris: Garnier, 1878), 181, noted this evasive precedent with disapproval in his review of Van Loo's painting. Van Loo's own pupil, Gabriel-François Doyen, either preceded or seconded his master with another version (oil on canvas, 156 × 190 cm, private collection) featuring a fully unveiled Agamemnon, but one that sets aside tragic inner conflict by having him turn to witness the celestial rescue by Artemis. I am very grateful to Perrin Stein of the Metropolitan Museum of Art for drawing my attention to this work.

16. See P. Seidel, *Les Collections d'œvres d'art du XVIIIᵉ siècle appartenant à l'empereur d'Allemagne*, trans. P. Vitry and Marquet de Vasselot (Berlin, 1900), 107, cited in Fullenwider, "'Sacrifice of Iphigenia,'" 545. Van Loo's doubts and long deliberation over the subject are manifested in the fully realized study for the composition now in the drawings collection of the Metropolitan Museum of Art. Among other differences, Agamemnon and Clytemnestra are on the right rather than the left side of the composition, while Calchas is on the right with his knife-hand lowered. Doyen's version preserves this arrangement.

17. Le comte de Caylus, *Description d'un tableau représentant le Sacrifice d'Iphigénie peint par M. Carle Van Loo* (Paris, 1757), 16–17; for a recent discussion of the painting in the 1757 Salon, see Mary Sheriff, *Fragonard: Art and Eroticism* (Chicago: University of Chicago Press, 1990), 35–38, and Fullenwider, "'Sacrifice of Iphigenia.'"

18. Caylus, *Description*, 26–27.

19. Fullenwider, "'Sacrifice of Iphigenia,'" 539, 547, offers the rather unlikely hypothesis that there was some deliberate reply to Winckelmann's having used Timanthes' Agamemnon in 1755 as the visual emblem of his argument for masking extreme passions in art.

20. For a summary discussion of these issues, see Montagu, *Expression of the Passions*, 1–8 and passim. Montagu eloquently counters the tendentious misunderstanding and disparagements of LeBrun's project in the art-critical and art-historical literature down to the present. While fully cognizant of its limitations and difficulties, she justly writes, "It is a monument to man's ability to comprehend the working of nature, and to use the artist's confidence in his power not to follow nature as an imitator, but to become a creator who, on the limited field of the canvas, could bring into being a world at once in conformity with natural laws, and free from natural imperfections" (8).

21. [Antoine Renou], "Lettre sur le Salon de 1757," in *Extrait des Observations périodiques sur la physique et sur les arts* (n.p., 1757), 7, 5. Melchior Grimm offered his subscribers to the *Correspondance Littéraire* a summary of the published debates engendered by Caylus and by Renou's negative reply. He identifies Renou (1731–1806), who would go on to become perpetual secretary of the Academy, only as "a student of M. Vien." Grimm reproaches Renou for the audacity of his critique but agrees at least with his assessment of the main character: "The grief of Agamemnon is common; here is a man who raises his eyes and arms to heaven; there is no genius in that sort of thing" (430). He reports an utterly novel iconographical suggestion from Diderot whereby Ulysses should have thrown his arms around his commander in order to block the view of the altar (431).

22. Étienne Falconet, *Traduction du XXXIV, XXXV et XXXVIe livre de Pline ancien avec des notes par M. Falconet* (Amsterdam, 1772), 168–77; Euripides, *Iphigenia in Aulis*, trans. P. Vellacott (New York: Penguin, 1972), 424.

23. Montagu, "Interpretations," 306–7, follows Falconet in this, which I question.

24. For basic data on the painting and related studies, see Pierre Rosenberg, *Fragonard*, exh. cat. (Paris and New York: Réunion des Musées Nationaux and Metropolitan Museum of Art, 1987), 210–20. Sheriff, *Fragonard*, 38–46, provides a valuable account of the sources and their imaginative synthesis in the painting, with a careful, highly detailed examination of its internal organization.

25. Pausanias, *Description of Greece*, vol. 1, trans. W. H. S. Jones (Cambridge, Mass.: Loeb Classical Library), 291–93.

26. Beth S. Wright, "New (Stage) Light on Fragonard's *Coresus*," *Arts Magazine* 60 (Summer 1986): 55, reviews the slight precedents in art.

27. The tragedy *Corésus et Callirhoé*, by Antoine de la Fosse, was produced in 1702; the opera *Callirhoé* was composed by André Cardinal Destouches with a libretto by Pierre-Charles Roy. On these texts and their tangential relation to Fragonard's conception, see Wright, "New (Stage) Light," 54–59.

28. See *Diderot on Art I: The Salon of 1765 and Notes on Painting*, trans. J. Good-

man (New Haven: Yale University Press, 1995), 141–48. See also Nathalie Volle, in *Diderot et l'art de Boucher à David*, eds. Marie-Catherine Sahut and Volle (Paris: Réunion des Musées Nationaux, 1984), 211.

29. Pausanias, *Description*, 366–67.

30. Jean Racine, *Iphigénie* (Paris, 1675), preface.

31. Wright, in "New (Stage) Light," 57–58, first raised the link to Racine, seizing upon the motif of Eriphile's self-stabbing, as the prototype for Coresus's action. She points out that a 1760 print by J. J. Flipart, illustrating the climax of Racine's tragedy, makes for one convincing visual bridge between the Van Loo *Iphigenia* and Fragonard's conception. Flipart's Artemis, removed from the need for any direct intervention, contentedly rests on a cloud above the action, occupying a parallel position to Fragonard's furious spirit. Wright also documents a good deal of contemporary interest in the staging of the sacrifice, which is only reported in Racine's text.

32. Pausanias, *Description*, 289.

33. On this improvised iconography, see the discussion by Sheriff in *Fragonard*, 42–45.

34. See the contemporary comment of the reviewer in the official *Mercure de France* (October 1765), 164–67, who disapprovingly notes "le caractère efféminé" of the head of Coresus and the equivocation between the figure of the priest, whose "draperie bouffante" over the chest obscures the anatomy necessary to distinguish the difference of age and sex that must obtain between them.

35. Diderot, *Salon of 1765*, 147. The remark in the dialogue is given to Grimm in a fictional dialogue.

36. Ibid., 145.

37. Ibid., 148.

INDEX

Page numbers in italics refer to illustrations

55, 110 (n. 10); role of Coppers in, 41–42, 49, 54, 55–56; suppression of, 50, 54, 55, 57; obligation in, 53–54; cultural function of, 53–56; European influence on, 54, 57; relation to capitalism, 55

Poussin, Nicolas: *Death of Germanicus*, 84, *86*

Powell, Jay, 108 (n. 23)

Preachers, endowed, 65, 66

Privatization: of state functions, 80

"Punishment of Avarice and Unchastity." *See* Moissac portal

Racine, Jean: *Iphigénie*, 91, 93–95, 114 (n. 31)

Reformation, iconoclasm during, 50, 65, 70, 103

Renaissance: visual symbols of, 105 (n. 1). *See also* Art history: Renaissance

Renou, Antoine, 113 (n. 21)

Retable altar pieces, 66, 68; winged, 64–65

Riemenschneider, Tilman: *The Altarpiece of Holy Blood*, 73, *74, 75, 76, pl. 8*

Rococo art, French. *See* Art: rococo

Romanesque art. *See* Art: Romanesque

Rothenburg: burghers of, 73, 75; St. Jakobskirche, *74, 76, pl. 8*

Rousseau, Jean-Jacques, 80, 96

Roy, Pierre-Charles, 113 (n. 27)

Royal Academy of Painting and Sculpture, French, 87, 91. *See also* Salons

Sacrifice: motifs of, 81, 98; substitution in, 82, 111 (n. 3); in the family, 99, 100; in David's *Lictors*, 101. *See also* Iphigenia, sacrifice of; Isaac, sacrifice of

Saint-Aubin, Gabriel: *View of the Salon of 1765*, 91, *92*

Sainte Marie, church of. *See* Souillac, abbey of

Salish people: masks of, 35–38, *37, 39, 46, pl. 1*; oral traditions of, 38; dances of, *39*. See also *Swaihwé*

Salons, of the French Royal Academy of Painting and Sculpture, 81, 111 (n. 1); of 1765, 91, *92*, 95; of 1761, 98; of 1757, 112 (n. 17)

Schapiro, Meyer, 6, 28, 32, 51; political activism of, 6, 25; reputation of, 6–7; 1939 European trip of, 7; and Walter Benjamin, 7; "Mozarabic to Romanesque in Silos," 7–8, 16; "The Sculptures of Souillac," 8, 11, 25; on Romanesque art, 8–9, 79; and Arthur Kingsley Porter, 8–11; social beliefs of, 9–10; on placement of Souillac portal, 13; on Souillac tympanum, 13–15, 19–20; on Souillac trumeau, 15–16, 45, 49, 52; decoding of aesthetics, 19; mode of analysis, 21, 102; and Franz Boas, 30

Sculptors: medieval, 9, 60; urban, 67–68, 70; contact with eastern European culture, 110 (n. 18)

Sculpture: Florid, 65, 66, 67, 73; cult, 79–80

—medieval: Schapiro's work in, 8; of Chartres, 32; Lévi-Strauss on, 32; of Moissac, 45, *48*, 49, *59*; monumental, 52; portable, 60. *See also* Portal sculpture; Souillac portal

Seaweed, Willie, 110 (n. 9)

Seligman, Kurt, 51–52, 53, 109 (n. 2)

Seven Years' War, 81, 91

Sheriff, Mary, 113 (n. 24)

Silos (monastery), 8, 16; Schapiro at, 9–10

Sophocles, 82, 94

Souillac, abbey of: local history of, 21–22; monks of, 66; architecture of, 106 (n. 18)